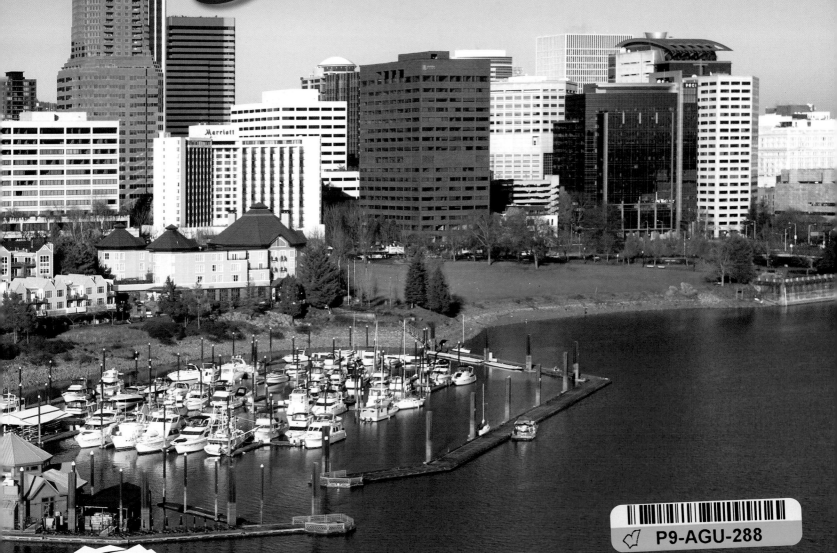

PORTLAND
impressions

FARCOUNTRY
PRESS

Photography by **Steve Terrill** • Introduction by **Craig Lesley**

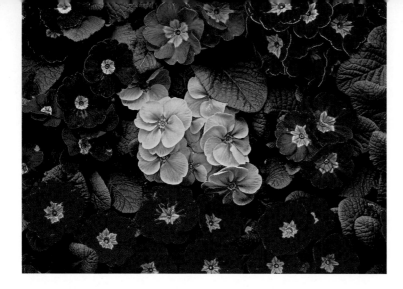

ABOVE: Spring primroses grace a garden in Portland. Because of the cool, wet winters and long, warm summers, flowers flourish in the Willamette Valley.

RIGHT: Purple asters and Himalayan blue poppies are reflected in dewdrops clinging to leaves.

TITLE PAGE: The downtown skyline overlooks the RiverPlace Marina along the Willamette River, which flows north through Portland on its way to the Columbia River.

FRONT COVER: Snow-capped Mount Hood looms in the background in this view of Portland's stunning skyline in fall.

BACK COVER: Colorful impatiens spill out of an antique wagon.

ISBN 10: 1-56037-347-4
ISBN 13: 978-1-56037-347-6

Updated in 2012
Photography © 2006 by Steve Terrill
© 2006 by Farcountry Press

For more information about our books write Farcountry Press, P.O. Box 5630, Helena, MT 59604; call (800) 821-3874; or visit www.farcountrypress.com.

Created, produced, and designed in the United States.
Printed in China.

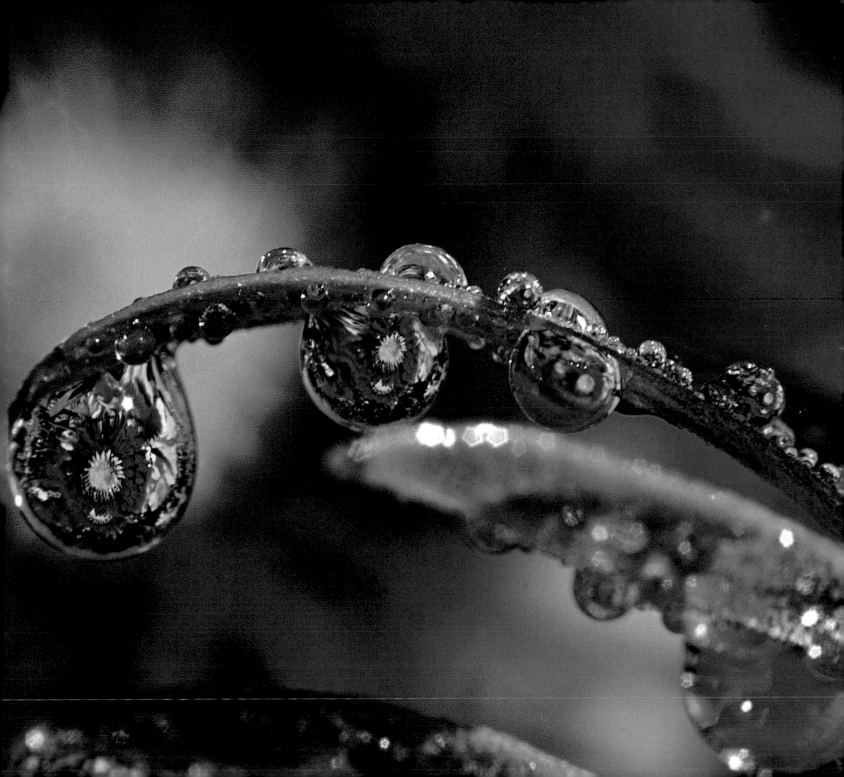

Introduction

by Craig Lesley,
**author of *Burning Fence,*
The Sky Fisherman, and *Winterkill***

Portland has a reputation for being wet. After growing up in sunny eastern Oregon, my first impression of Portland was rain, rain, and more rain. Because most of my books are set east of the Cascades, where I spent my youth, very

little rain dampens the pages. But now, after twenty-five years of living in the city, I think of water, not rain.

Two of my favorite Portland sights are the burbling historic water fountains, nicknamed "Benson Bubblers" after Simon Benson, their sponsor. (I find them irresistible.) And dozens of other fountains, such as Salmon Springs, attract joyful children and frolicking dogs.

Both the Willamette and Columbia Rivers bless Portland with opportunities for fishing, sightseeing, and other water recreation. When I'm walking on the Vera Katz Eastbank Esplanade or along Tom McCall Waterfront Park, I never tire of seeing the water, the boats, the winging seabirds.

In fact, many of Portland's activities are associated with the rivers. The arrival of the Rose Festival Fleet every June signals the beginning of summer festivities on the riverbanks. Portlanders remark that it usually rains during the internationally famous Rose Festival Parade, but after that, the weather clears. The waterfront park hosts other events well into the fall—most notably the Blues Festival and Bones and Brew. The Bite of Oregon is an event that gives top restaurants across the state a chance to showcase their specialties.

Portland enjoys several monikers. While most Oregonians know it as the City of Roses, others realize its second nickname is the City of Bridges. And Steve Terrill's photographic impressions capture those elegant spans. Within these pages are photos of majestic Cathedral Park under the enchanting St. John's Bridge. The Hawthorne Bridge, one of the main arteries from Southeast to downtown Portland, features illuminated art displays on its frame and girders. The Interstate Bridge and the Sam Jackson Bridge are both utilitarian and

beautiful, serving as the vital connectors between Oregon and Washington.

Some people call Portland the City of Bikes. The League of American Bicyclists has honored Portland with a gold award for bicycle friendliness. Many business people bicycle to work daily, come rain or shine. On Bike-to-Work day, thousands of "spokeheads" join the commute. Portland also hosts the Providence Bridge Pedal, where the ten Willamette River bridges are closed to vehicle traffic, and as many as 20,000 bikers take advantage of the opportunity to cycle the bridges without the distraction of cars and busses.

While the Yellow Bicycle program—which placed public bicycles in strategic locations across the city and invited citizens to ride a yellow bike to their destinations, then leave the bicycle there for the next rider—sadly failed, Oregon still has a long history of bicycle activism. In 1971, it was the first state to pass a law designating that one percent of the Highway Fund went to bike lanes and pedestrian routes. Every year since 1988, thousands of cyclists sign up for Cycle Oregon.

Is there a connection between those who love to bike and those who love to read? Maybe. Reading books, perhaps because it's so rainy here, stands out as Portland's quietest pastime. As the photograph of Powell's City of Books indicates, Portland is a city of readers. The downtown Multnomah County Library carries the distinction of being the most widely used library in the country (per capita), and all the branch libraries are well-thumbed, too.

While Powell's is the largest independent bookseller in the region, other independents also flourish downtown and in nearby neighborhoods. Broadway Books, Annie Bloom's, and The Looking Glass hire helpful, book-minded staff who recommend good literature to the many readers who support these independents. St. Helens Book Shop, Third Street Books in McMinnville, and Oregon Book Company in Oregon City serve towns close to Portland.

As the readership might suggest, Portland is also a city of writers—hundreds of them. While the inkslingers read and sign books at all the stores, they also gather at friendly watering holes to drink coffee and beer, have lunch, discuss strategies, and commiserate with their colleagues. Like Paris or Prague, Portland has many cafés and hangouts frequented by writers. My favorite haunt is the Alameda Café on Northeast Fremont. Georjean Melonas, a huge supporter of writers and artists, offers her café as a unique venue for readings and gatherings. While grabbing a cup of coffee or sipping a beer, I'm likely to encounter novelist Molly Gloss, nonfiction writer Larry Colton, witty Oregonian columnist Jonathan Nicholas, fashion writer Vivian McInerny. Since the Alameda Café is also Steve Terrill's favorite hangout, we often meet there to brainstorm book ideas.

No doubt Portland's many great colleges and universities contribute to this fervor for books and reading. The University of Portland students enjoy great teachers and a beautiful view from the bluffs. The university's *Portland Magazine* has won numerous accolades. As students Lewis and Clark College peruse their books, they can overlook the scenic Willamette River. Reed College is unconventional and quirky, still drawing many of its erudite scholars from the East Coast.

Portland State University thrives in the heart of downtown Portland. Serving over 17,000 students annually PSU—like the city itself—is egalitarian, attracting people

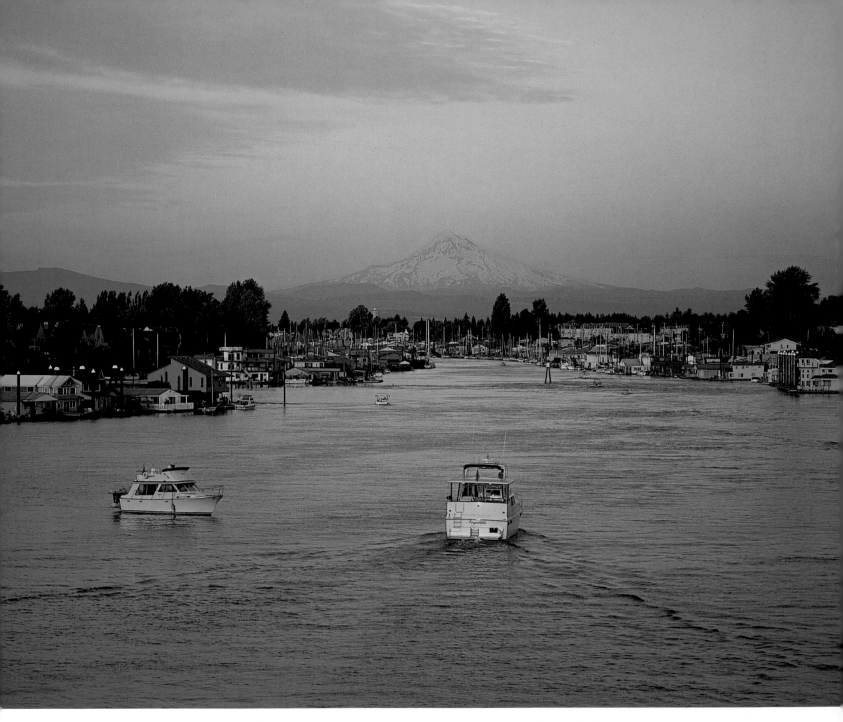

ABOVE: With a sunset-burned image of Mount Hood in the background, pleasure boats cruise the North Portland Harbor on the south side of Hayden Island.

from all ages, ethnic groups, and socioeconomic backgrounds. Among its many excellent programs, the university is particularly well known for its urban studies and creative writing programs. PSU has almost everything—including a Native American long house.

I asked long-time friend and storyteller Ed Edmo what Portland meant to him. Ed and I are both about the same age and grew up close to one another. I was born and raised in The Dalles and he comes from the tiny railroad town of Wishram, just across the river from Celilo Village. Both of us grew up on the Columbia River, east of the Cascades on the dry side of Oregon.

"Rain," Ed said. "Rain and neon."

"Neon?" I asked. Then I remembered two venerable Portland landmarks—the White Stag and the 7Up sign. "What else?"

"The deer statue downtown in the park and Meier and Frank. The old Newberry store."

"The Lloyd Center," I said, "Before it was enclosed, and the giant Christmas tree seemed to reach the heavens." Then I added, "And cruising Broadway."

Small town boys, we always thought we'd meet wild city girls, but we never did; they must have pegged us as rubes.

"Remember the amusement park at Jantzen Beach," Ed said. "I remember the Fat Lady, how she was always laughing and shaking around."

Then I remembered all sideshow acts from when the carnival visited The Dalles each summer. In my memoir *Burning Fence,* I describe a fearful encounter with the Two-

Faced Man that gave me nightmares for months. Still, I was always eager to come to Portland for the Ringling Brothers Circus, the Centennial Exposition, and sundry amusements.

Now, some of the old signposts and events have disappeared, obscured by time, torn down for renewal. Fortunately however, in this magnificent collection of photographs, Steve Terrill has captured important present-day impressions for all who love the city. This book is a gift—from a first-class photographer to those viewers who delight in a first-class city.

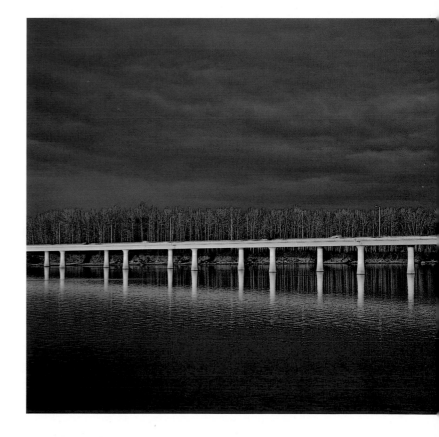

RIGHT: Evening light on the Glenn Jackson Bridge, which spans the Columbia River between Oregon and Washington.

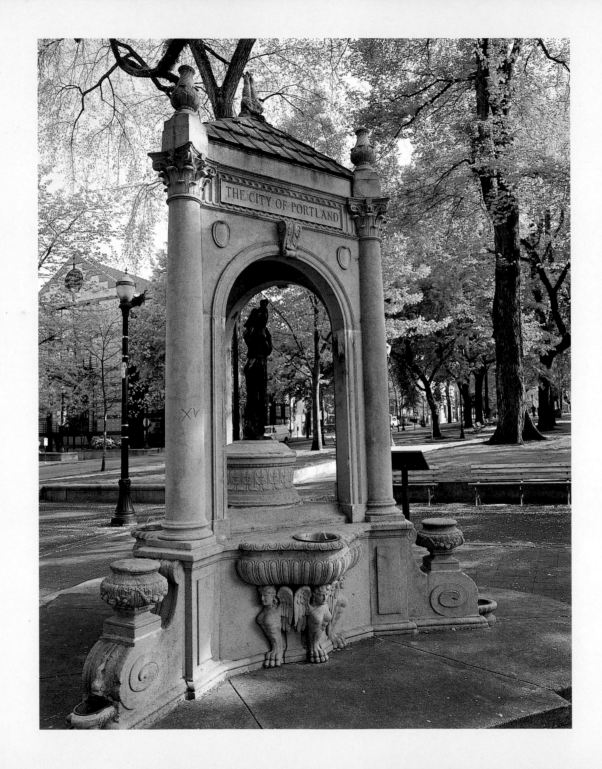

FACING PAGE: Located in the South Park area between Southwest Salmon and Main streets, the Shemanski Fountain recounts the biblical legend of Abraham's search for a bride for Isaac. The bronze and sandstone fountain was designed in 1926 by Oliver Barrett and Carl Linde and was a gift to the city from Joseph Shemanski.

BELOW: The Buckley Center and Science Hall on Franz Hall Quad at the University of Portland, Oregon's Catholic university.

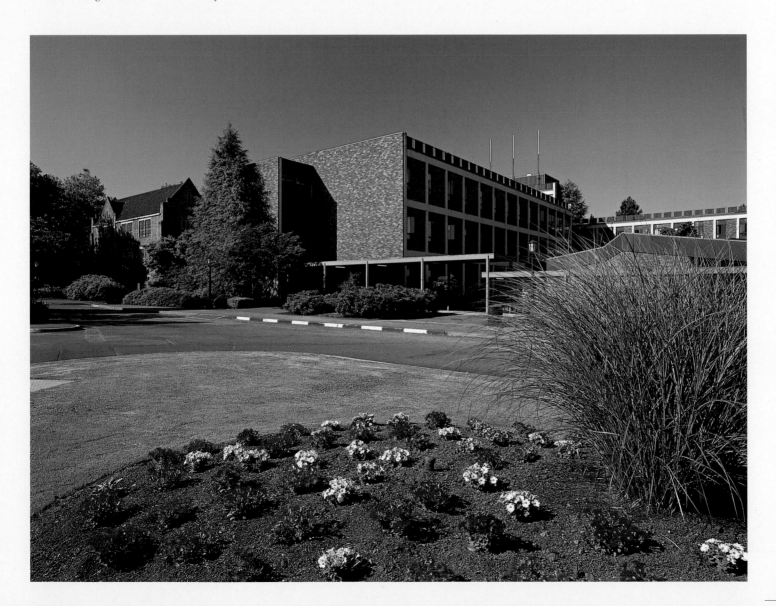

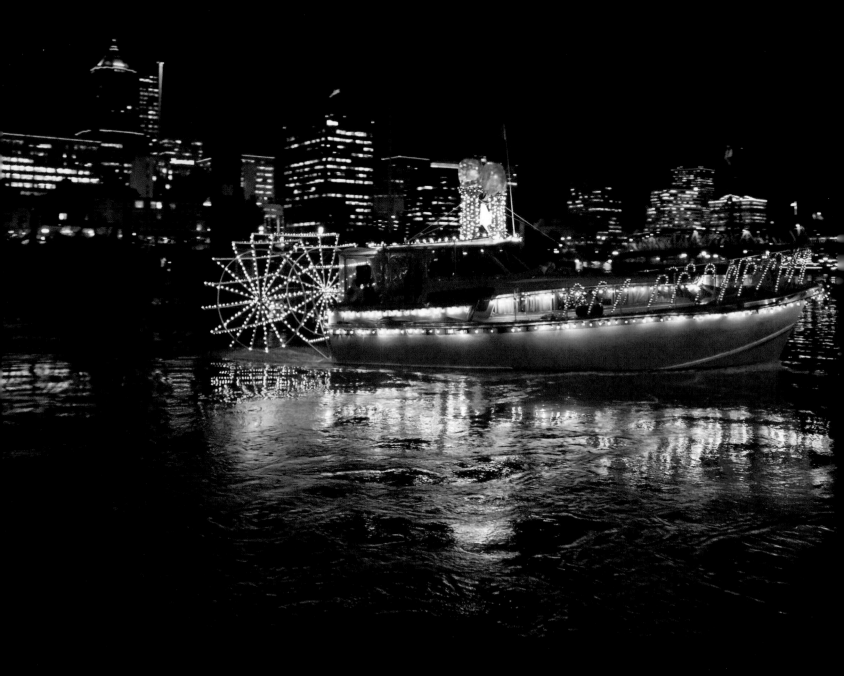

LEFT: The Christmas Ship Parade, a Portland tradition since 1955, transforms the Willamette River into a sparkling wonderland. More than sixty boats, adorned in lights, dazzle crowds for two weeks before Christmas each year.

BELOW: A porthole peek at the campus of Lewis and Clark College, which was founded in 1867 as the Albany Collegiate Institute.

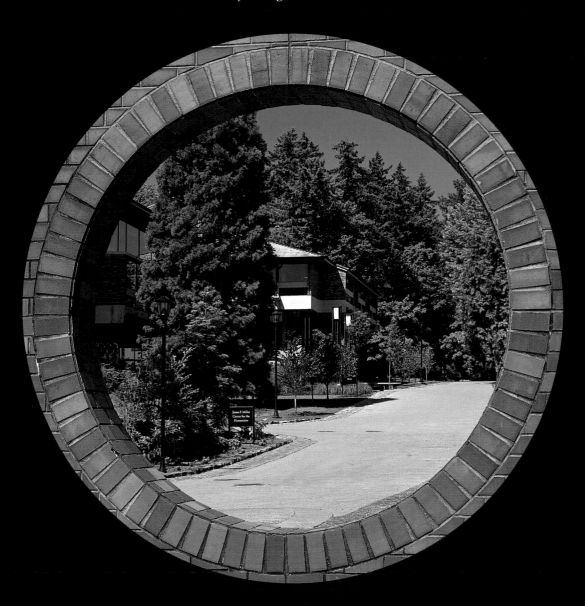

RIGHT: The Interstate 5 Bridge spans the Columbia River, the boundary between Oregon and Washington.

BELOW: The Earle A. and Virginia H. Chiles Center is a 5,000-seat event center at the University of Portland.

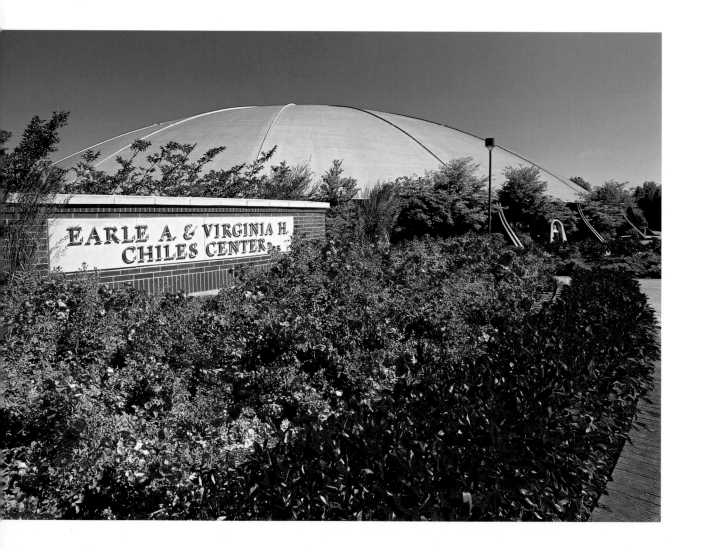

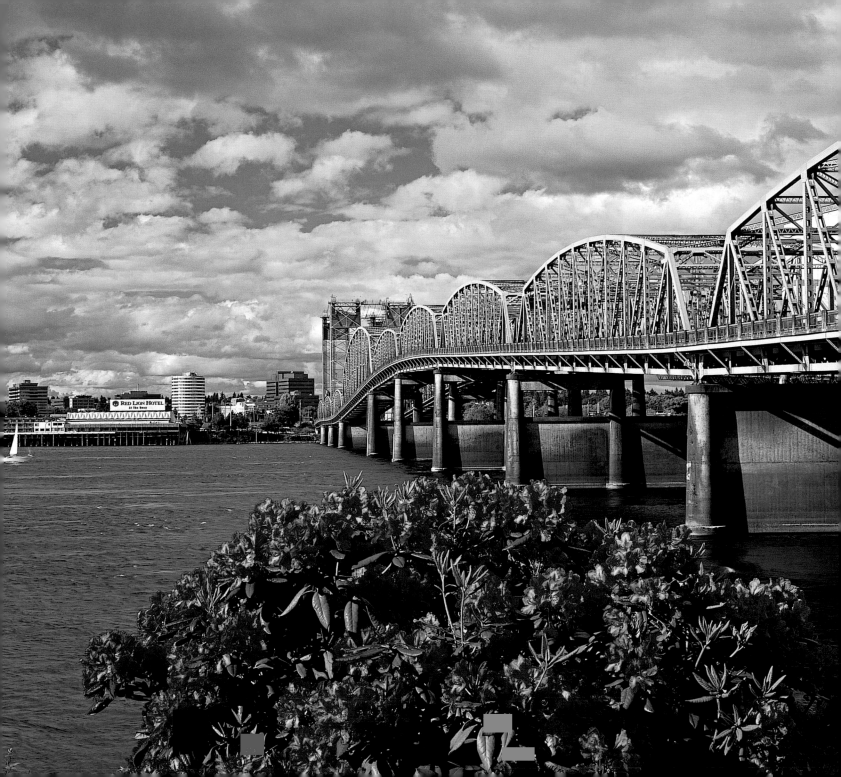

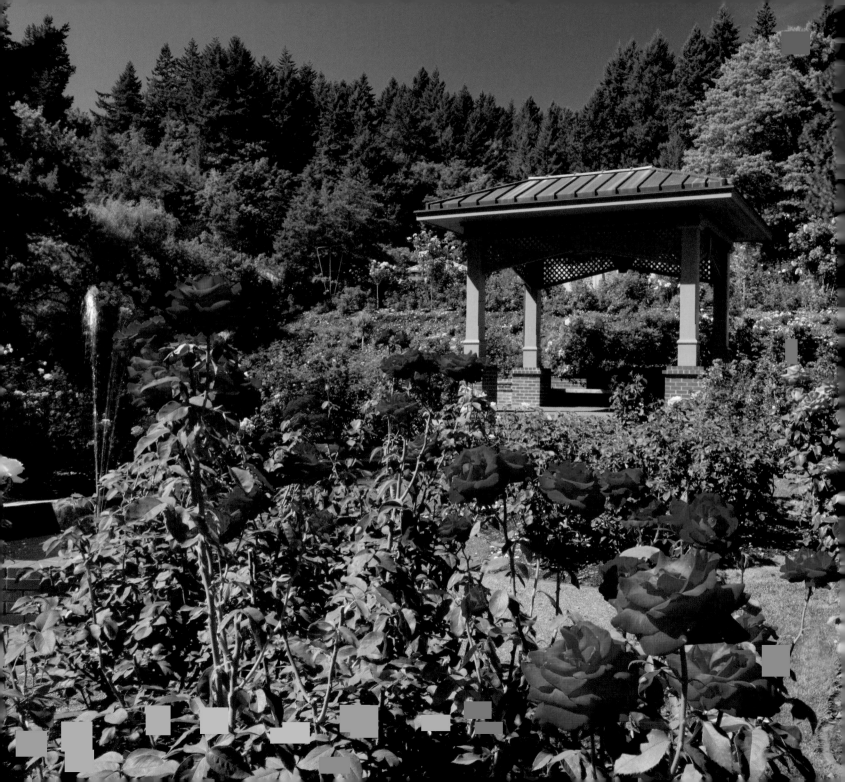

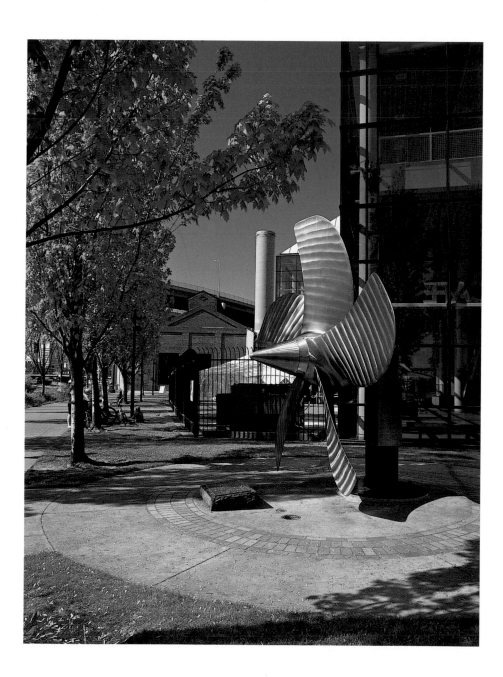

LEFT: The propeller from the USS *Blueback* submarine—the Navy's last non-nuclear, fast-attack submarine that appeared in the movie *The Hunt for Red October*— is displayed at the Oregon Museum of Science and Industry, better known as OMSI.

FAR LEFT: Founded in 1917, Portland's International Rose Test Garden is the oldest continuously operated public rose test garden in the nation. During World War I, hybridists in Europe sent roses to Portland's garden in order to keep the hybrids from being destroyed. Today the gazebo in the Gold Medal Garden (pictured) is often the site of weddings and other special events.

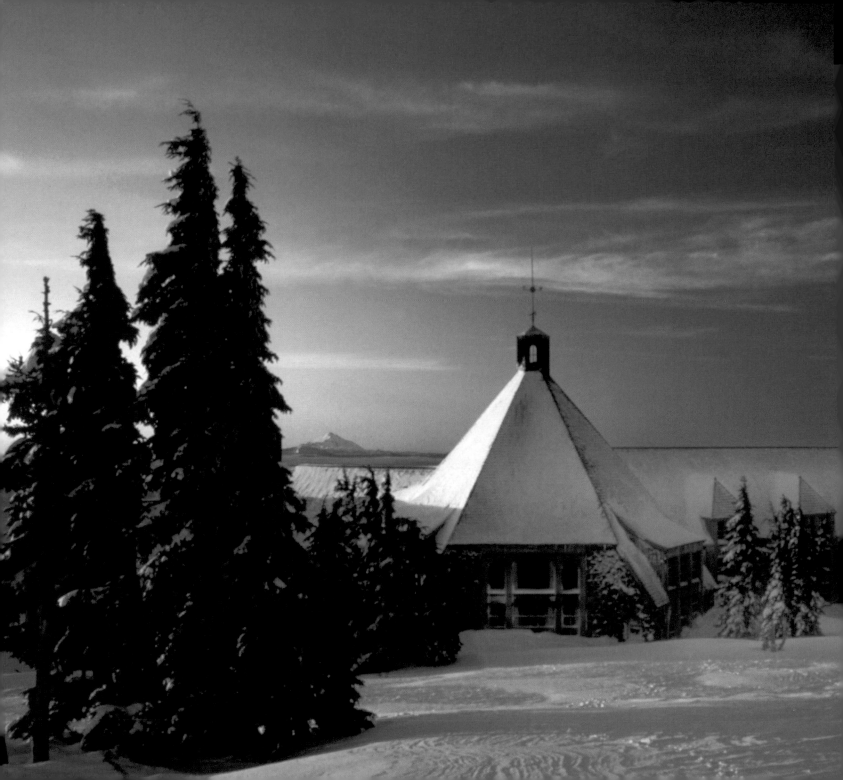

LEFT: Built in 1936 by craftsmen hired by the Works Progress Administration, Timberline Lodge on Mount Hood is a popular spot for downhill skiing and snowboarding.

BELOW: Snow coats the Strolling Pond Garden of the Japanese Gardens in Washington Park. Opened in 1967, the gardens were designed by Professor Takuma Tono, a world-renowned authority on Japanese garden landscaping.

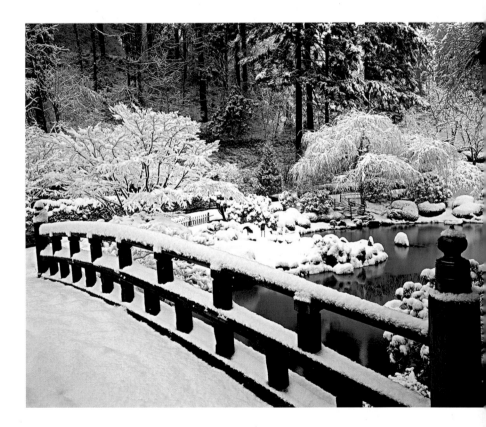

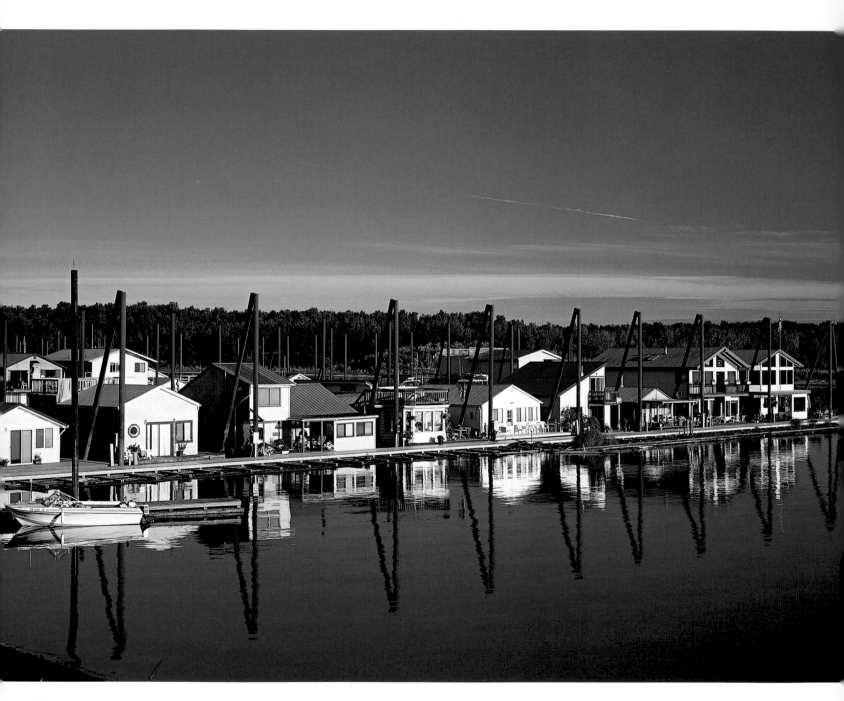

FACING PAGE: In Northeast Portland, whole neighborhoods of houseboats are moored along the Columbia River.

BELOW: A great way to experience Portland's historic bridges and waterfront is by tour boat. You might also spot bald eagles and osprey nesting along the river.

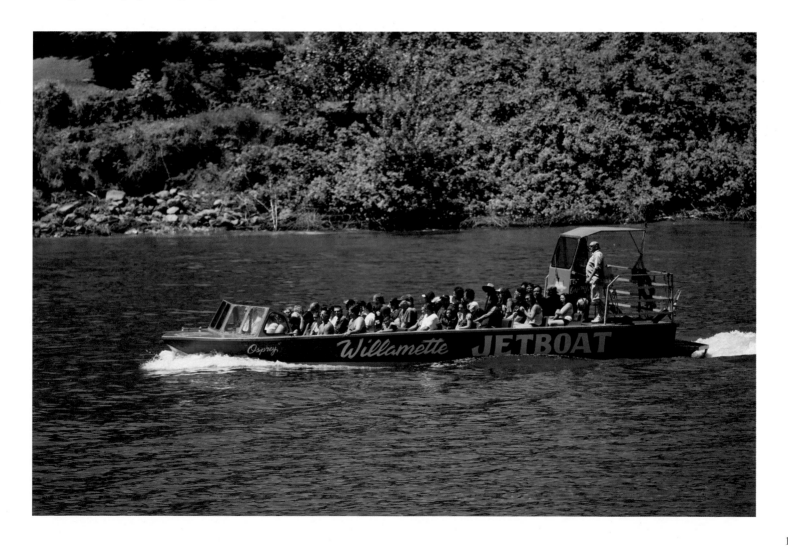

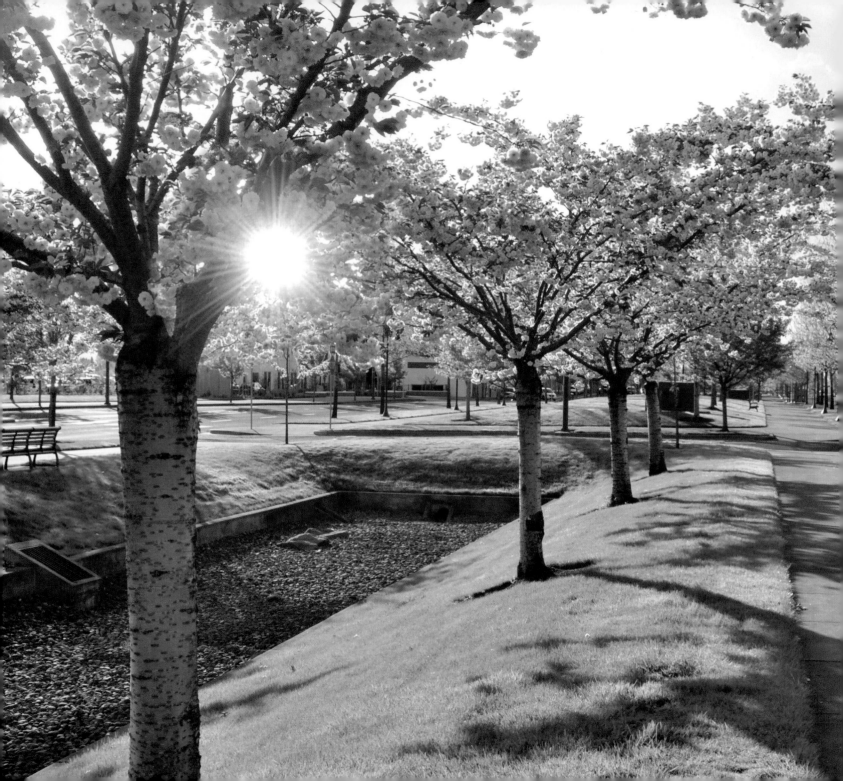

LEFT: Gorgeous pink cherry blossoms put on a dazzling show in March or April each year in Portland.

BELOW: Portland's Cinco de Mayo festival in Tom McCall Waterfront Park bills itself as the largest fiesta outside of Mexico.

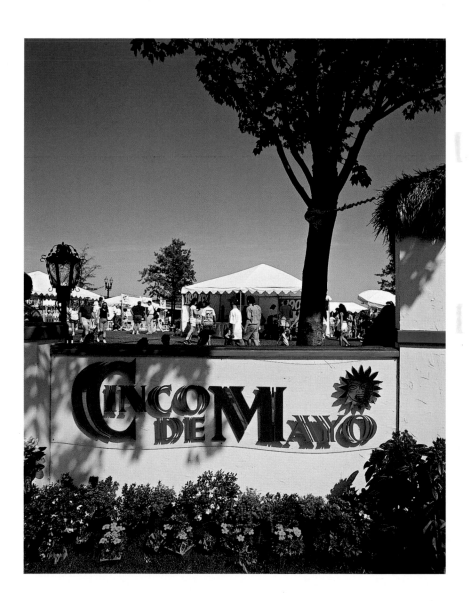

RIGHT: From the prom-
enade along the Willamette
River at McCormick Pier,
joggers can see the 1973
Fremont Bridge and the
1913 Broadway Bridge,
Portland's longest draw-
bridge.

FAR RIGHT: The centerpiece
of Jamison Square, in the
Pearl District, is a fountain
that simulates a shallow
tidal pool. At the edge of
the fountain is a sculpture
of a brown bear called
Rico Pasado, meaning "rich
past"—an homage to the
bears that roamed the area
long ago.

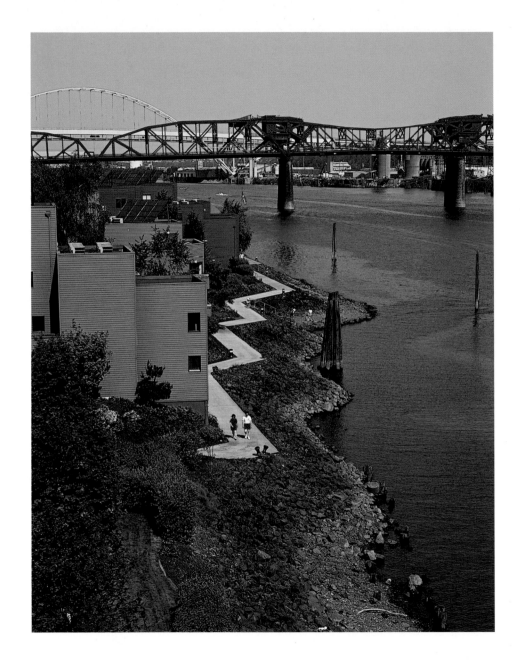

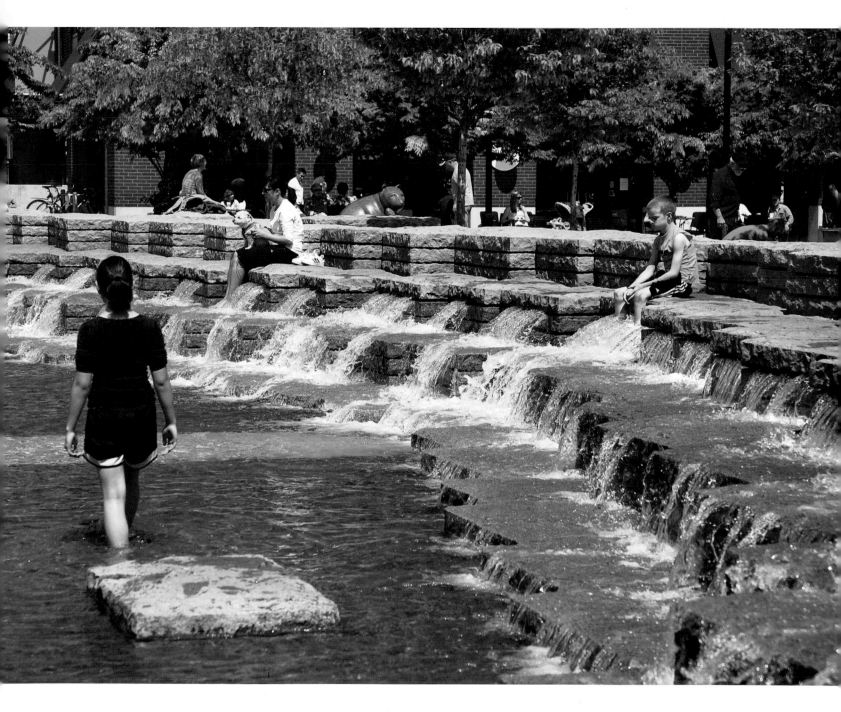

RIGHT: Each year since 1987, crowds of up to 120,000 gather for the four-day Waterfront Blues Festival at Tom McCall Waterfront Park.

BELOW: Featuring a sixty-five-foot marquee, the 2,776-seat Arlene Schnitzer Concert Hall was built in 1928 on Southwest Broadway Street and is an excellent example of Italian Rococo Revival architecture.

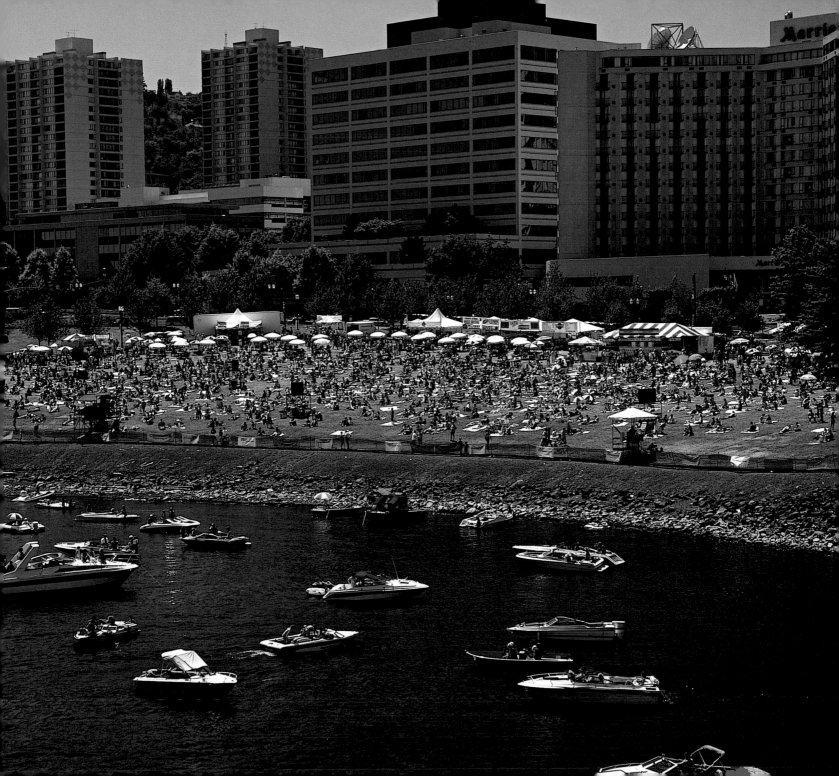

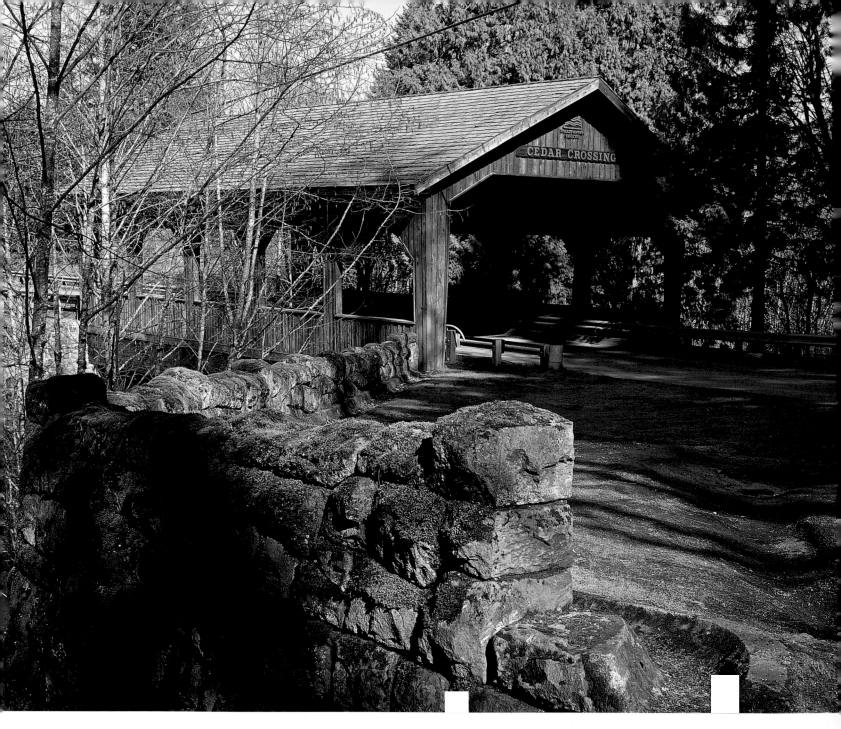

FACING PAGE: Sixty-foot Cedar Crossing Bridge spans Johnson Creek in Southeast Portland. It is not considered a "true" covered bridge because it is not supported with a wooden truss.

RIGHT: This Asian elephant is enjoying a snack at the Oregon Zoo, which is recognized for its successful Asian elephant–breeding program.

BELOW: This giraffe and marabou stork wander the Africa Savanna Exhibit at the Oregon Zoo, which was founded as the Washington Park Zoo in 1887.

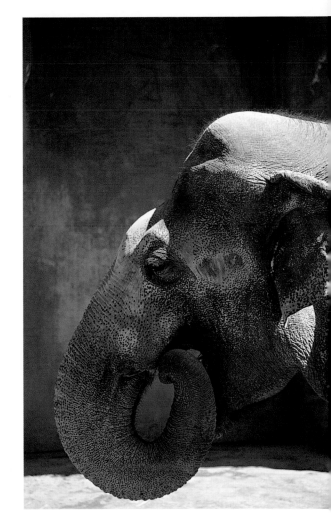

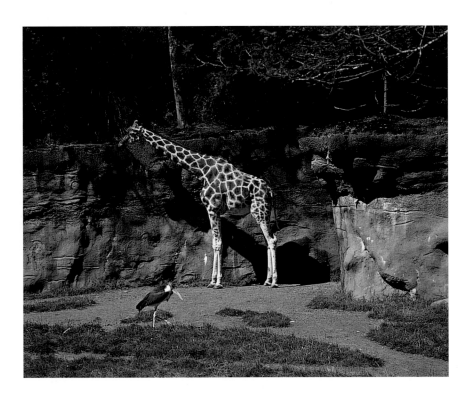

RIGHT: Flaming maple trees frame a view of the 150-foot clock tower of Portland's Union Station. The hub of transportation when it was built in 1895, the train station is an example of Italian Renaissance architecture and is made of brick, stucco, and sandstone.

BELOW: Awash in scarlet maple leaves, these row houses in Northwest Portland are part of a city tradition that started with the 1855 Park Street rowhouses.

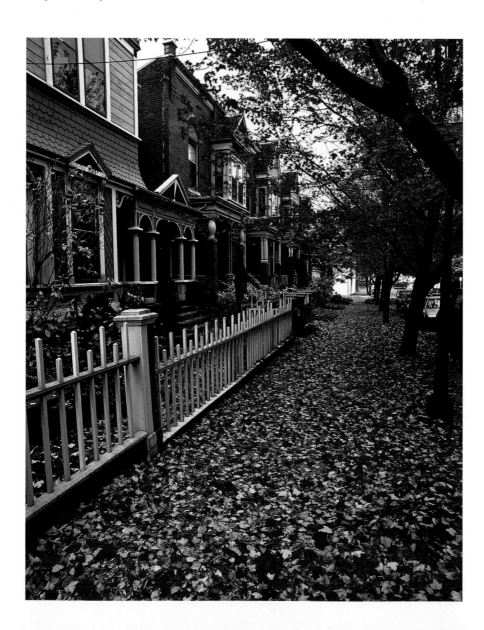

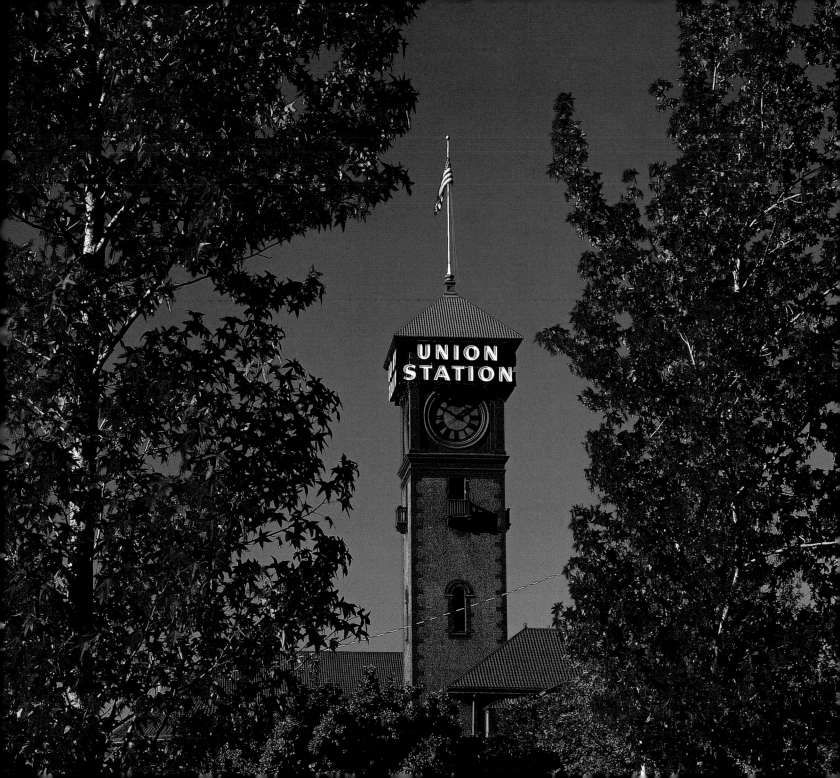

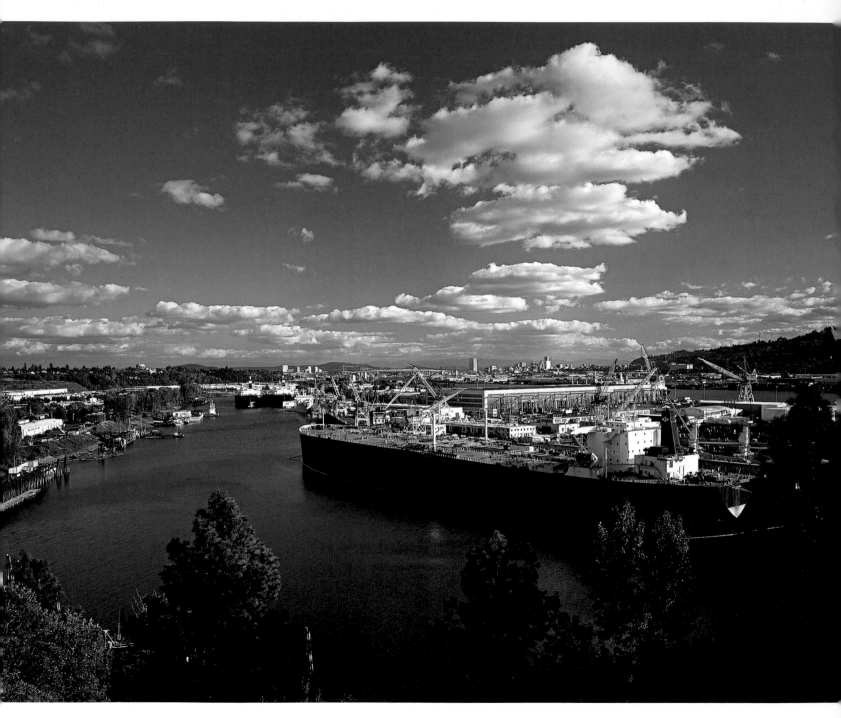

FACING PAGE: The Port of Portland, a major harbor in the Pacific Northwest for much of the nineteenth century, is currently the third largest port on the West Coast.

BELOW: Located at the east end of the 1931 Saint Johns Bridge, Cathedral Park was the campsite of William Clark and eight men from the Corps of Discovery on April 2, 1806.

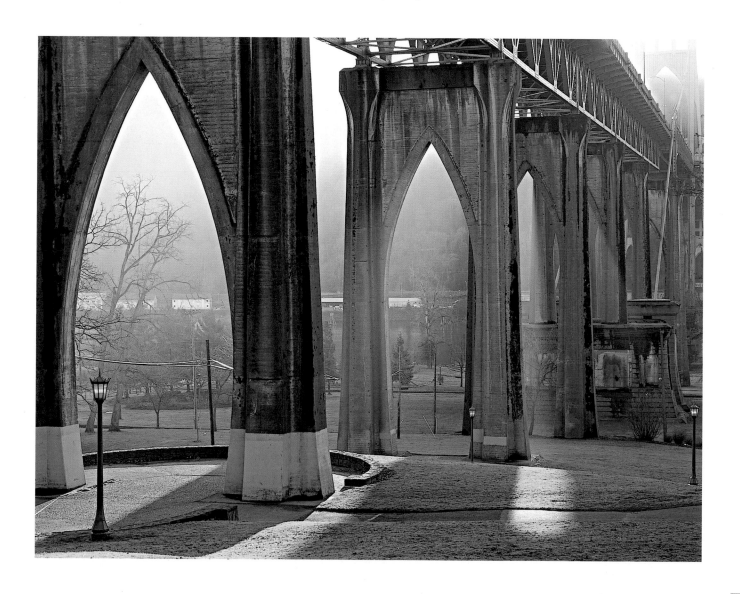

RIGHT: The purple peak of 11,129-foot Mount Hood, the fourth-largest mountain in the Cascades, is reflected in the sunrise-colored Columbia Slough.

BELOW: The Metropolitan Area Express (MAX) Light Rail races to its next stop, with Mount Hood rising in the background. The MAX connects downtown Portland with Beaverton, Clackamas, Gresham, Hillsboro, North/Northeast Portland, and the Portland International Airport.

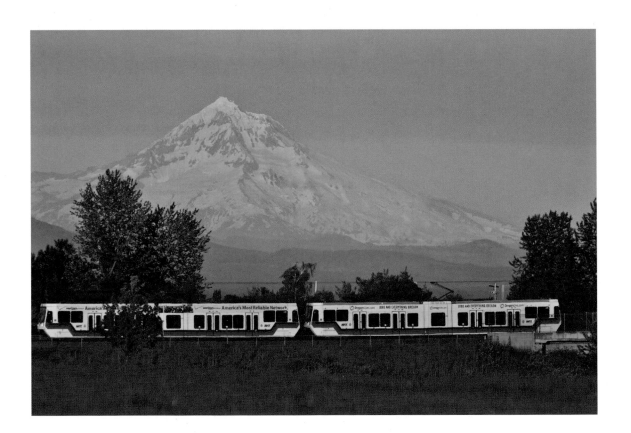

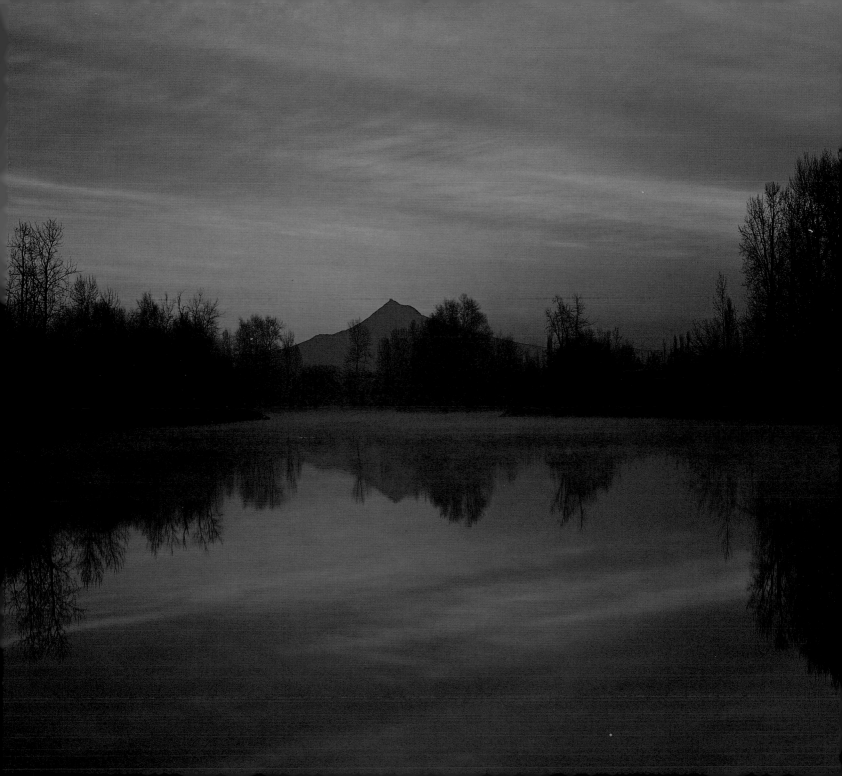

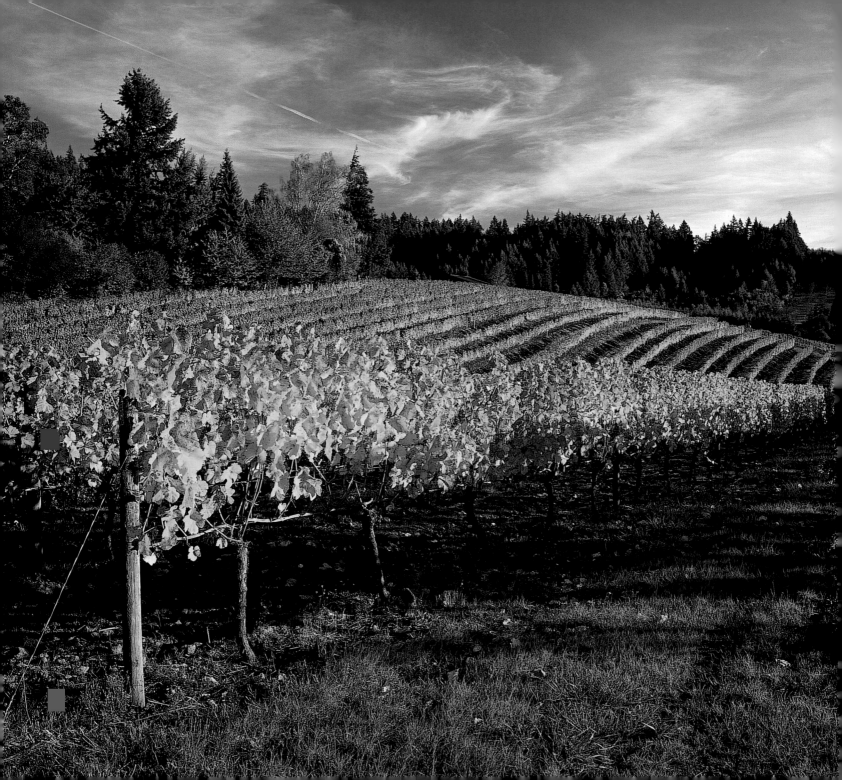

LEFT: Evening light falls on the orderly rows of grapevines in the Willamette Valley's Yamhill County, the heart of Oregon wine country, with more than 200 wineries.

BELOW: These pinot noir grapes flourish in Washington County, a wine-growing region between the Tualatin and the Coast ranges specializing in pinot noir, chardonnay, and riesling varietals.

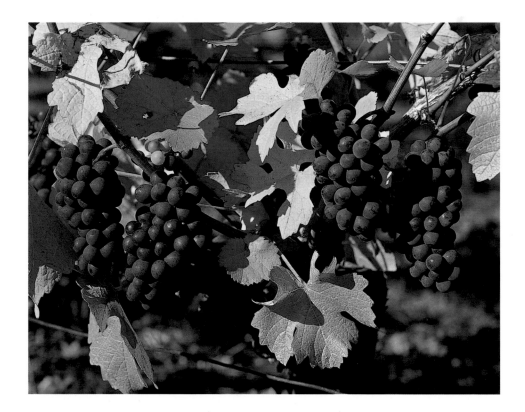

BELOW: A street vendor barbeques at Pearl in the Park, an arts celebration held in North Park Blocks, an urban park in Portland's Burnside neighborhood.

BELOW: The summertime Fremont Fest parade is sponsored by the Beaumont Business Association, an organization devoted to preserving the livability of this Portland neighborhood on east Fremont Street.

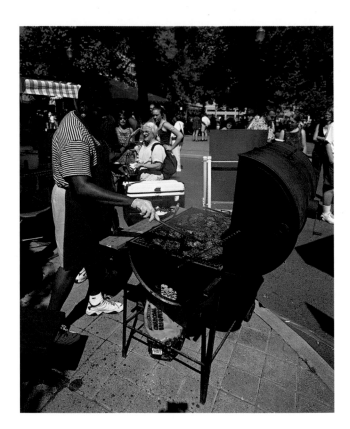

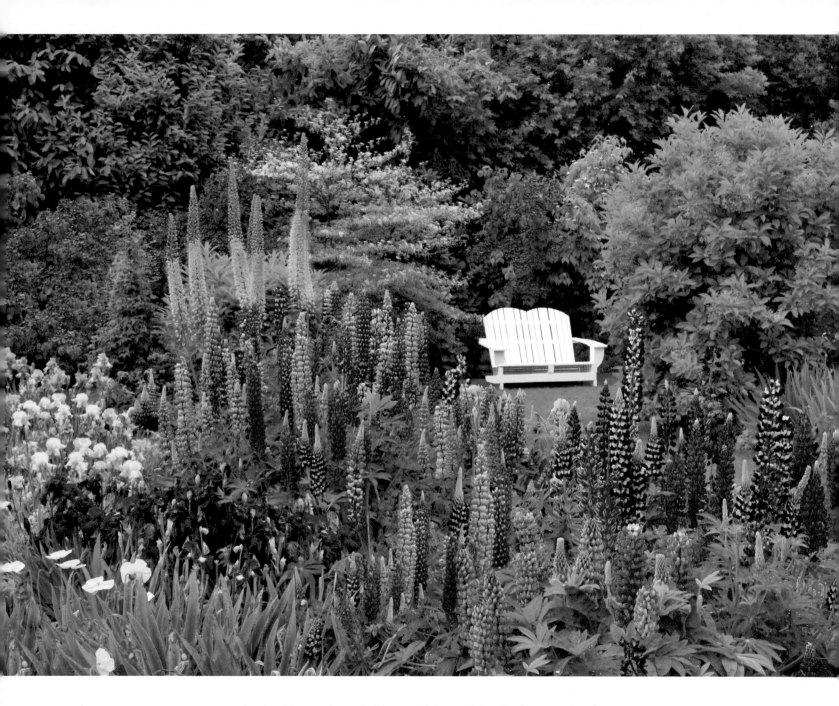

ABOVE: Lupine, irises, and poppies bloom in Schreiner's Iris Gardens near Brooks, Oregon. The Willamette Valley's wet, mild climate makes for spectacular gardens.

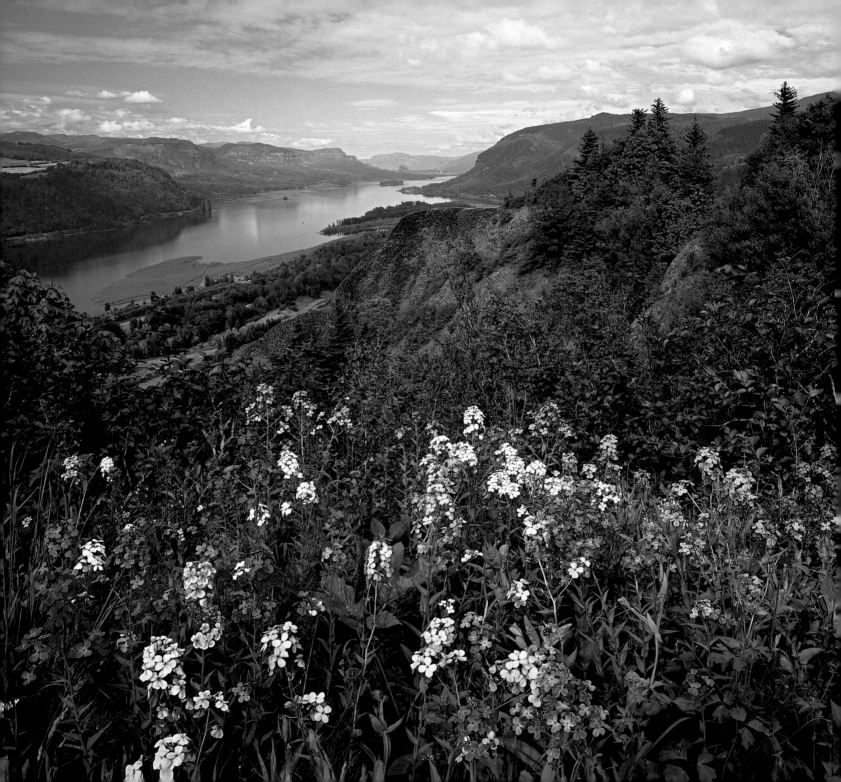

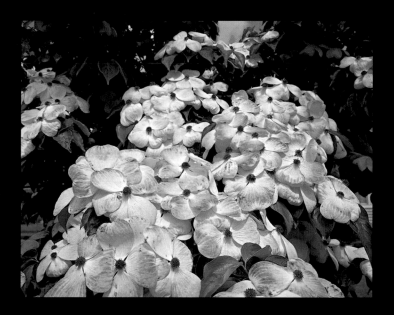

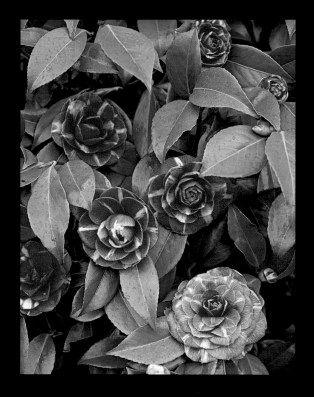

ABOVE: The blushing pink blossoms of Pacific dogwood trees are a common sight in the coastal area of Washington and Oregon.

RIGHT: The intense pink of these variegated camellia blossoms is set off by the glossy green foliage. Walk through any Portland neighborhood and you can see camellia bushes growing fifteen to twenty feet high.

LEFT: White and pink dame's rockets, as well as rust-colored columbine flowers, adorn this overlook of the eighty-mile-long Columbia River Gorge.

RIGHT: This giant Douglas-fir tree, which began its life around 1323 and was cut for the 1959 Oregon Centennial, is displayed at the World Forestry Center in Washington Park. Started in 1966, the Cascadian-style center has recently undergone a $7.5-million renovation and features a museum, two tree frames, and raft rides and simulated smoke jumping and for children.

FACING PAGE: This display at the Discovery Museum of the World Forestry Center covers the diverse species of trees and uses of wood around the world.

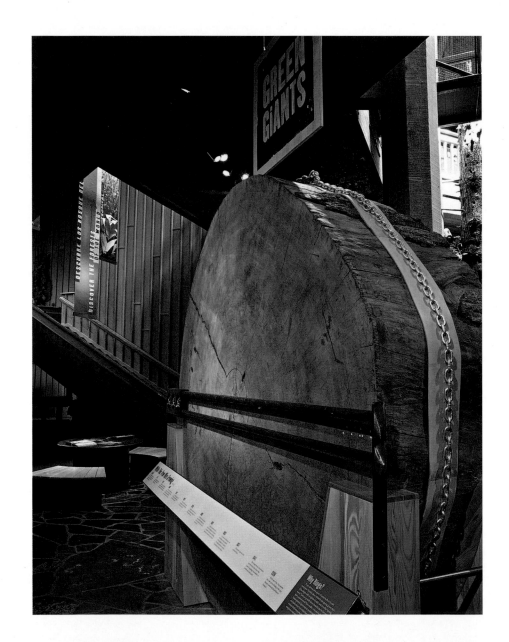

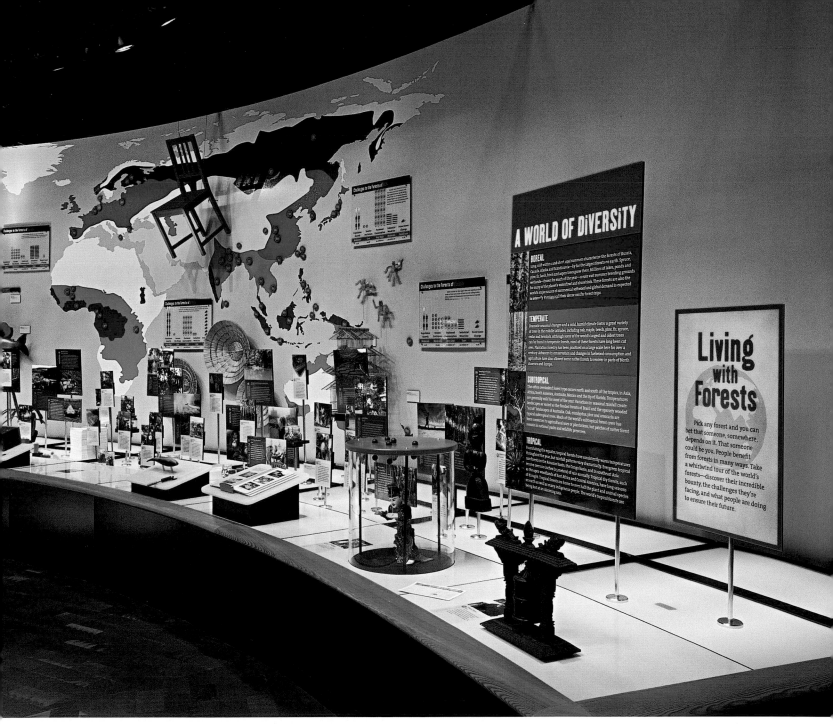

A WORLD OF DIVERSiTY

BOREAL

Long, cold winters and short, cool summers characterize the forests of Russia, Canada, Alaska and Scandinavia—by far the largest forests on earth. Spruce, pine, fir, larch, birch and aspen trees grow there. Millions of lakes, ponds and wetlands—frozen for much of the year—create vast summer breeding grounds for many of the planet's waterfowl and shorebirds. These forests are also the world's major source of commercial softwood and global demand is expected to intensify. Russians call their dense conifer forest taiga.

TEMPERATE

Dramatic seasonal changes and a mild, humid climate foster a great variety of trees in the middle latitudes, including oak, maple, beech, pine, fir, spruce, cedar and hemlock. Although some of the world's largest and oldest trees can be found in temperate forests, most of these forests have long been cut over. Plantation forestry has been practiced on a large scale here for over a century. Advances in conservation and changes in fuelwood consumption and agriculture have also allowed some native forests to recover in parts of North America and Europe.

SUBTROPICAL

This often-overlooked forest type occurs north and south of the tropics, in Asia, Africa, South America, Australia, Mexico and the tip of Florida. Temperatures are generally mild for most of the year. Variations in seasonal rainfall create landscapes as varied as the flooded forests of Brazil and the sparsely wooded "scrub" landscape of Australia. Oak, eucalyptus, pine and araucaria are typical subtropical trees. Much of the world's subtropical forest cover has been converted to agricultural uses or plantations, but patches of native forest remain in national parks and wildlife preserves.

TROPICAL

Found along the equator, tropical forests have consistently warm temperatures throughout the year, but rainfall patterns vary dramatically. Evergreen tropical rainforests in the Amazon basin, the Congo basin, and in southeast Asia receive over 100 inches (2.5 meters) of rain annually. Tropical dry forests, such as the open woodlands of East Africa and Central America, have long seasons of drought. Tropical forests are home to over half the plant and animal species on earth, as well as many indigenous peoples. The world's tropical forests are being lost at an alarming rate.

Living with Forests

Pick any forest and you can bet that someone, somewhere, depends on it. That someone could be you. People benefit from forests in many ways. Take a whirlwind tour of the world's forests—discover their incredible bounty, the challenges they're facing, and what people are doing to ensure their future.

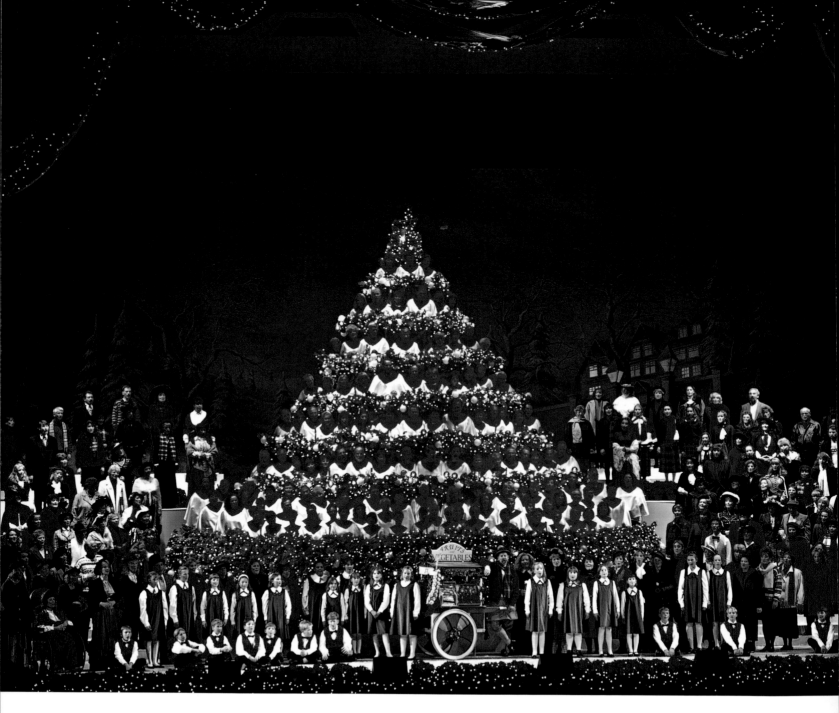

ABOVE: "The Singing Christmas Tree," hosted by the Central Tabernacle, has been an annual event since 1962 and features hundreds of singers on a rotating Christmas tree built of cast aluminum that supports up to 40,000 pounds.

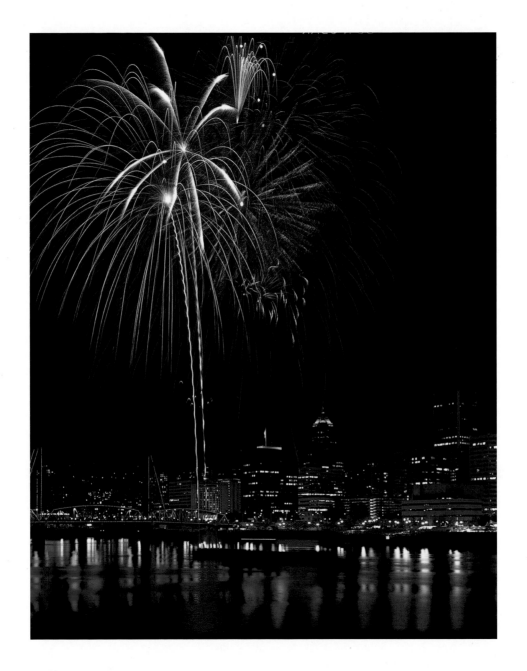

LEFT: Fireworks burst over the Willamette River on the opening weekend of the month-long Portland Rose Festival. A celebration of the flower that thrives in this climate, the festival has been a signature event in the area since its start in 1907 and now features sixty events, including the Grand Floral Parade.

RIGHT: The brilliant colors of flowers, both indigenous and cultivated, grace the brick walkways of Pioneer Courthouse Square during the annual Festival of Flowers.

BELOW: Nasturtium and evergreen clematis flowers thrive along a white picket fence on Northeast Sixtieth Street.

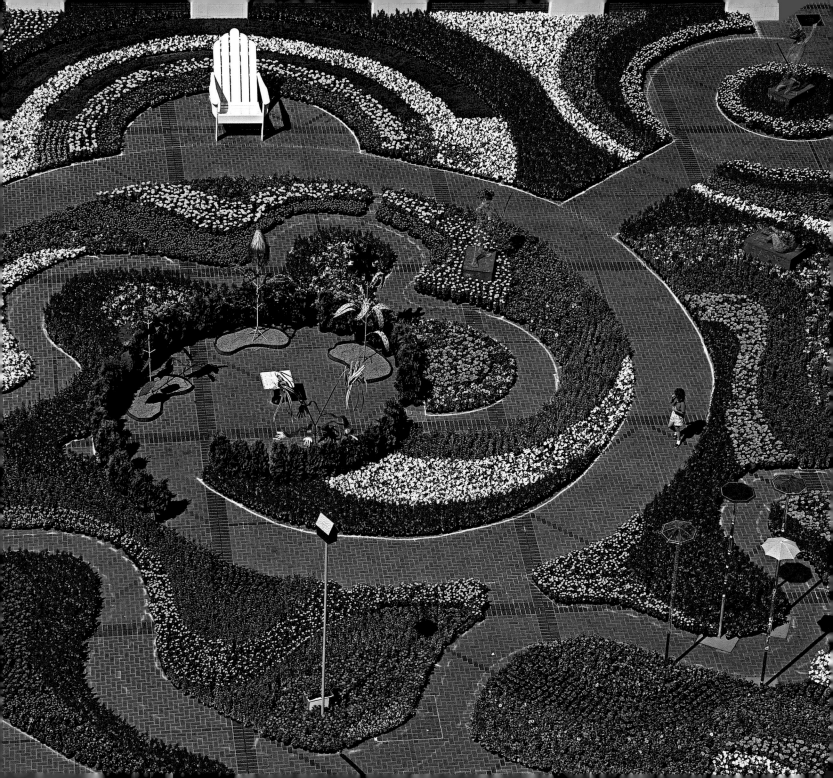

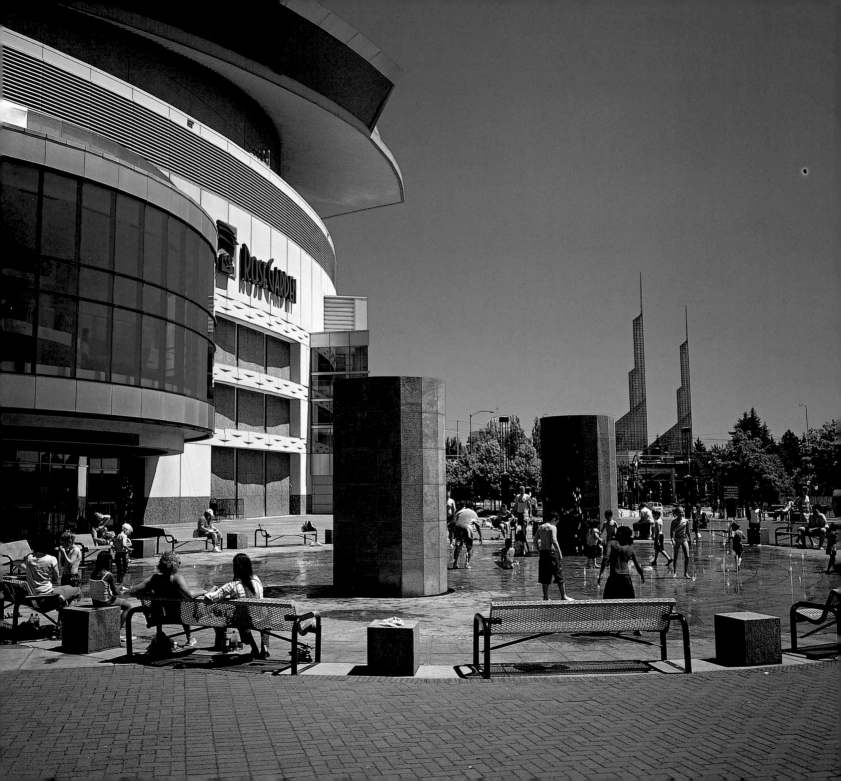

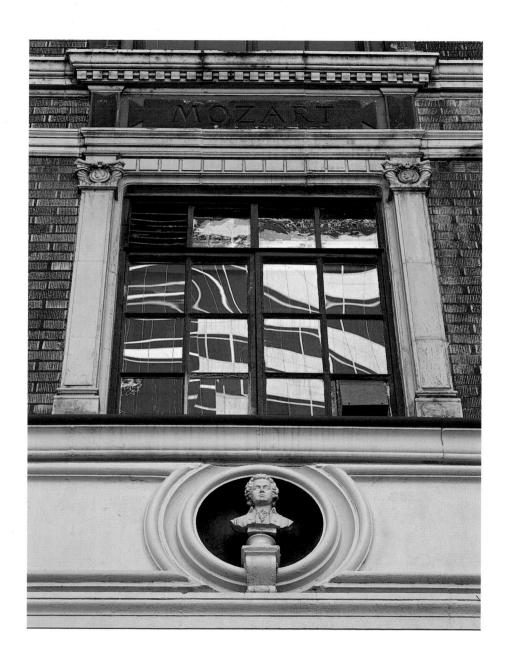

LEFT: Stonework and a bust of composer Wolfgang Amadeus Mozart appear on the side of the Studio Building in Portland's downtown.

FACING PAGE: Children cool off in the fountain in front of the Rose Garden Arena, a 785,000-square-foot facility for entertainment and athletic events that is home of the Portland Trail Blazers basketball team.

FACING PAGE: The oldest building on the University of Portland campus in north Portland, Waldschmidt Hall was built in 1890 and restored in 1992.

BELOW: A streetcar glides through the Pearl District, Portland's best-known art district. The Pearl is an award-winning, internationally recognized leader in urban renewal and has been called the "gold standard" for live, work, and play mixed-use space.

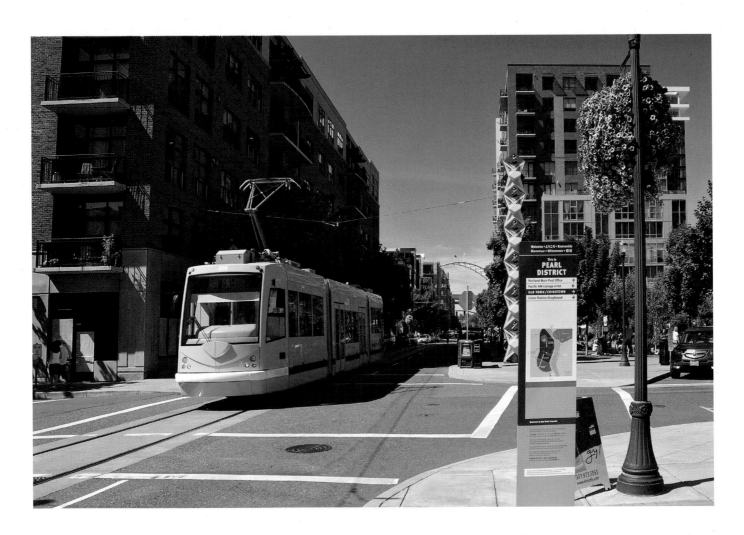

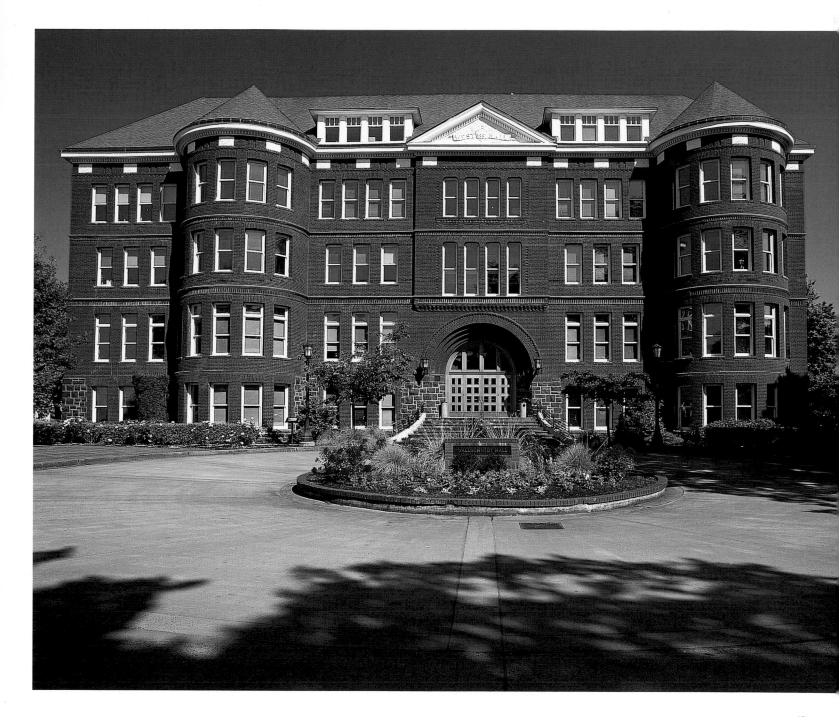

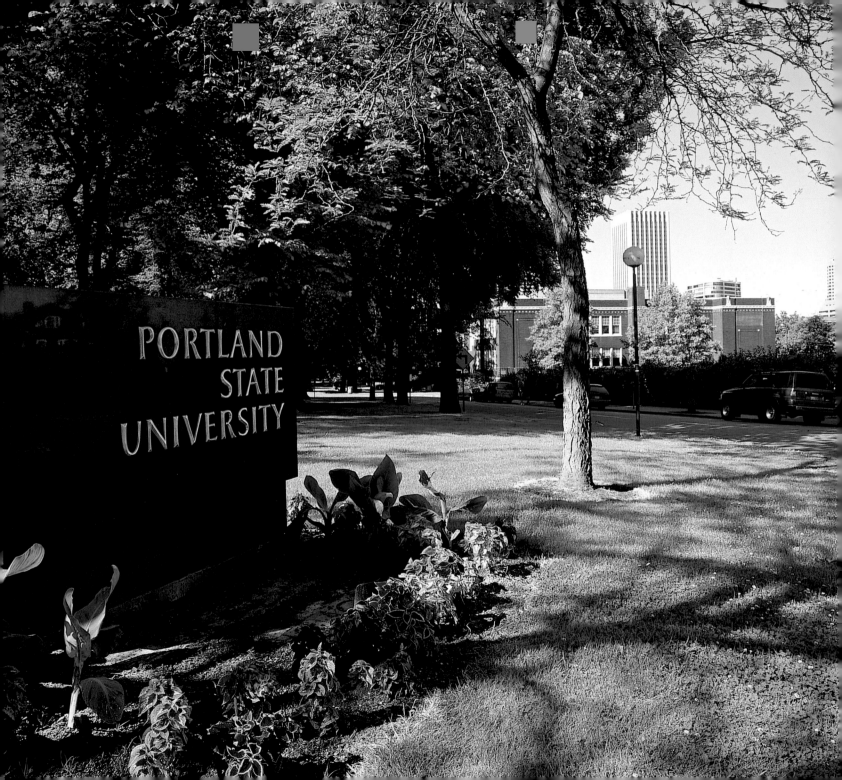

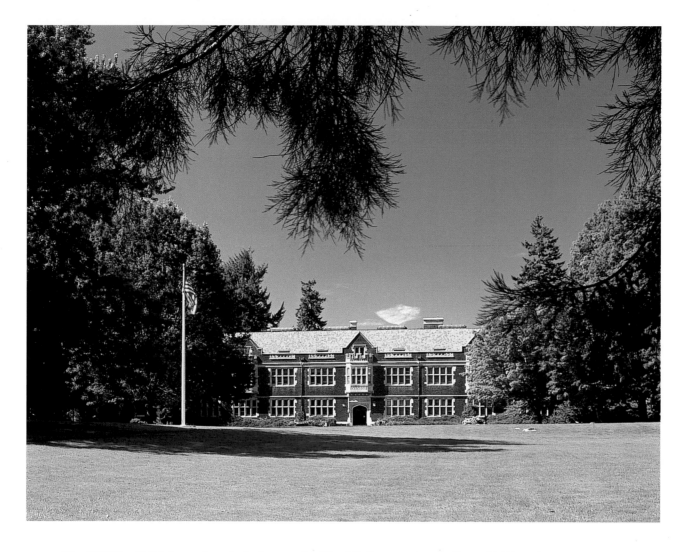

ABOVE: The 1912 Eliot Hall is located on the lush grounds of Reed College, a private college of 1,340 students.

FACING PAGE: Portland State University has nearly 24,000 students and is considered Oregon's largest urban university.

RIGHT: This vintage trolley is one of four that provide historical tours of Portland. Since 1872, when the first horse-drawn streetcar appeared in this city, thirty companies have provided streetcar service in the City of Roses.

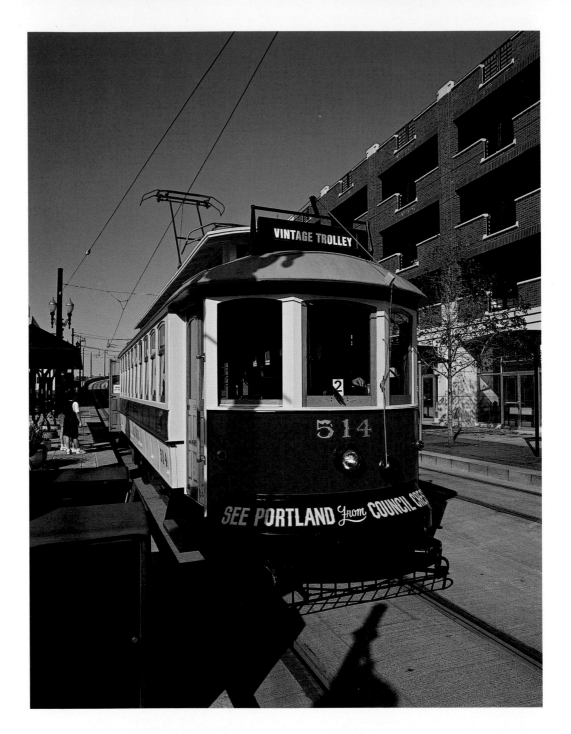

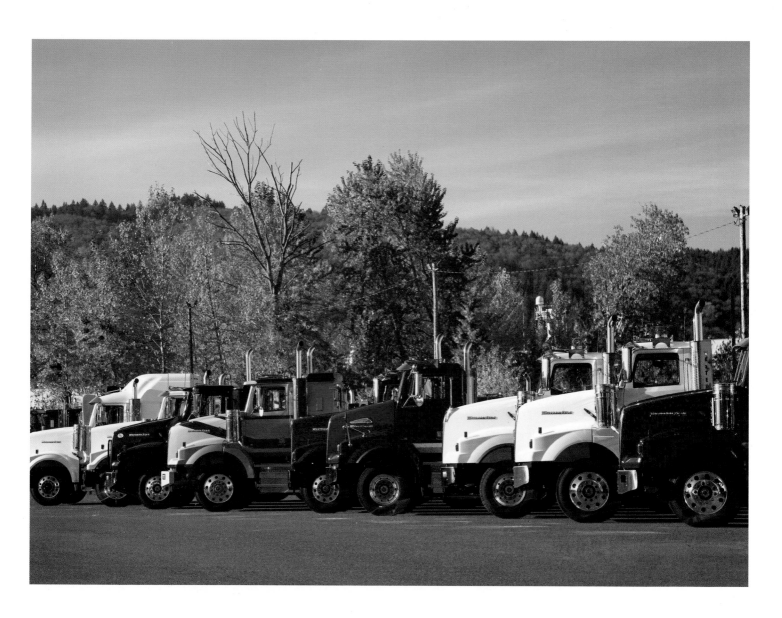

ABOVE: Newly built Western Star trucks get ready to hit the road. Located on Swan Island, Western Star manufactures highly customized heavy-duty trucks for use in the mining, logging, oil, and other industries.

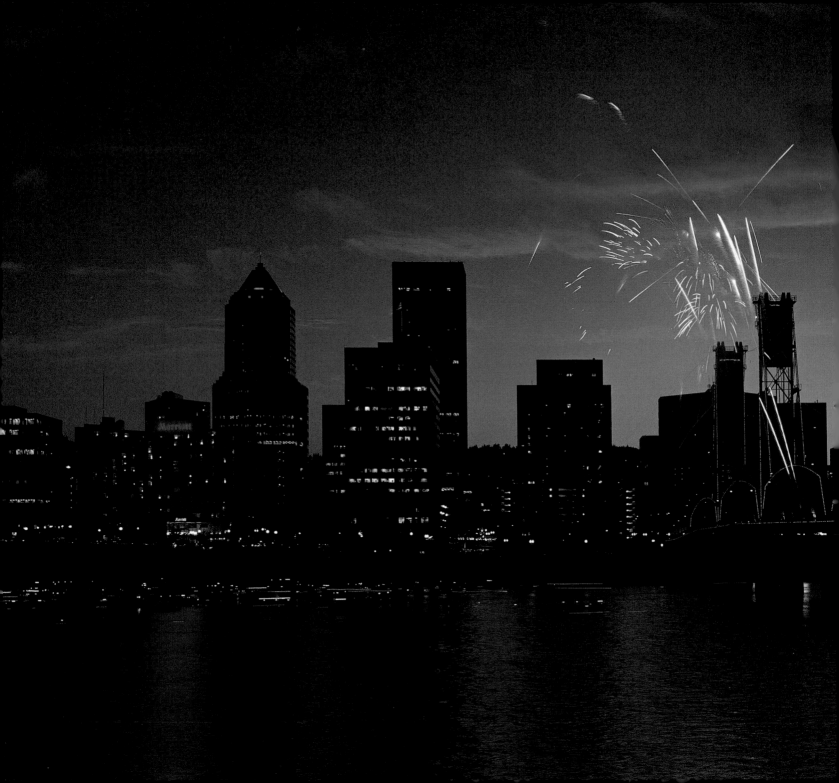

ABOVE: A sunflower is etched against
a red sky and setting sun.

LEFT: Against a backdrop of Portland's
downtown skyline, fireworks explode
at the 1999 reopening of the Hawthorne
Bridge after a year-long, $21.8-million
renovation. Built in 1910, the Hawthorne
Bridge is the world's oldest vertical-lift
bridge.

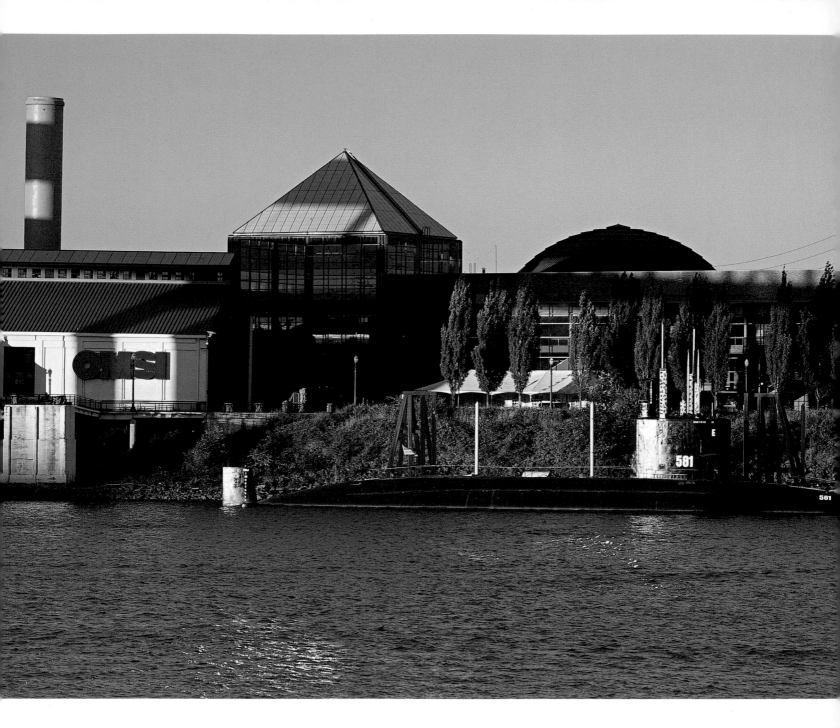

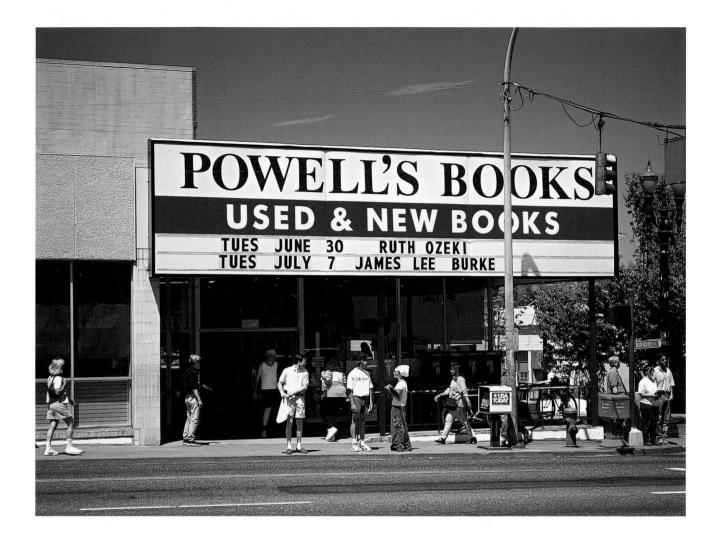

ABOVE: Since its beginning in 1971, Powell's Books has grown into one of the world's largest new-and-used bookstores. In addition to seven other stores in metropolitan Portland and a large mail-order business, Powell's main store is housed in a three-story, block-long building on Burnside Street.

FACING PAGE: The USS *Blueback,* which is on permanent display at OMSI, is a $21-million submarine that was launched in 1969 and decommissioned in 1990. Its name is the common name given to sockeye salmon.

RIGHT: The thirty-six-foot-tall sculpture of hammered copper called *Portlandia,* on the Portland Building, was sculpted by Raymond Kaskey and is based on a female figure in Portland's city seal who welcomes traders into the port of the city.

FAR RIGHT: Obscured by mist, the two-mile-long Interstate 205/ Glenn Jackson Bridge was finished in 1983 and connects Portland and Vancouver, Washington.

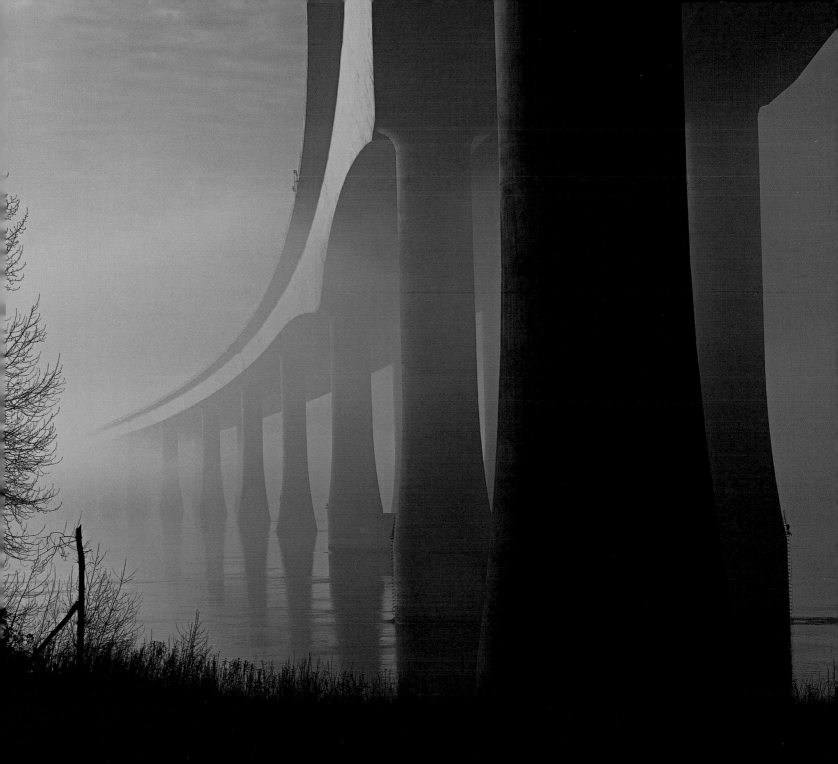

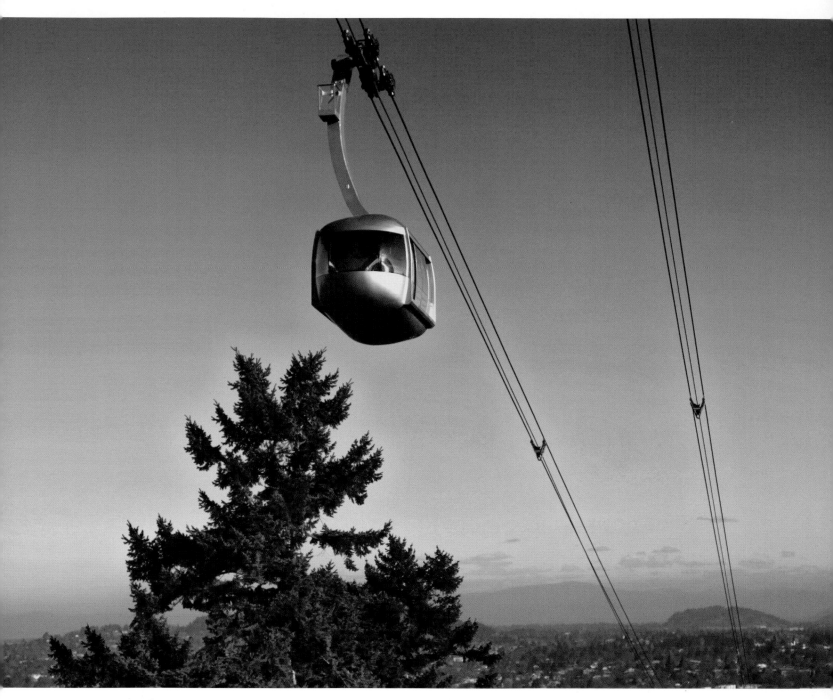

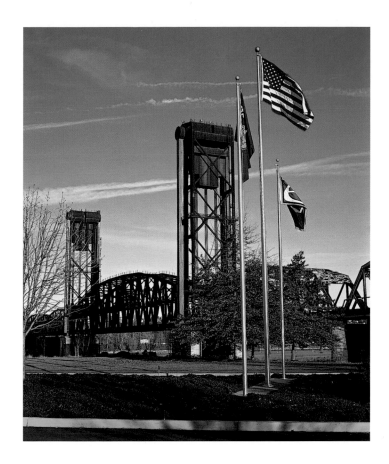

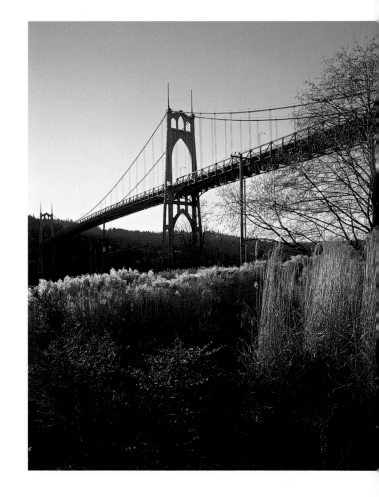

ABOVE: The Burlington Northern Railroad Bridge 5.1, which spans the Willamette River, is a truss bridge with a vertical lift. The "5.1" denotes the rail mileage from Portland's Union Station.

RIGHT: The Gothic-towered Saint Johns Bridge, Portland's only suspension bridge, was designed by internationally renowned bridge architect David B. Steinman. It crosses the Willamette River near the community of Saint Johns in metropolitan Portland.

FACING PAGE: Part of Portland's public transportation system, the Portland Aerial Tram travels 3,300 linear feet between the South Waterfront terminal adjacent to the Oregon Health and Science University's Center for Health and Healing and the terminal at the Kohler Pavilion on OHSU's main campus.

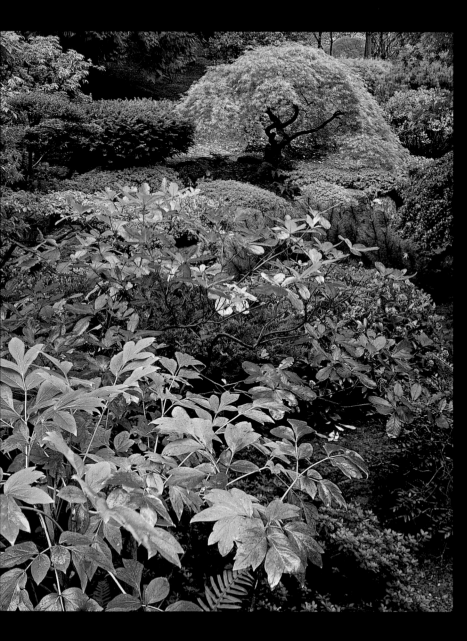

RIGHT: In fall, bright-orange and yellow beech trees line the quaint city streets of Northeast Portland.

BELOW: Fall paints the leaves of the Natural Garden, part of the Japanese Gardens, tucked into Portland's West Hills.

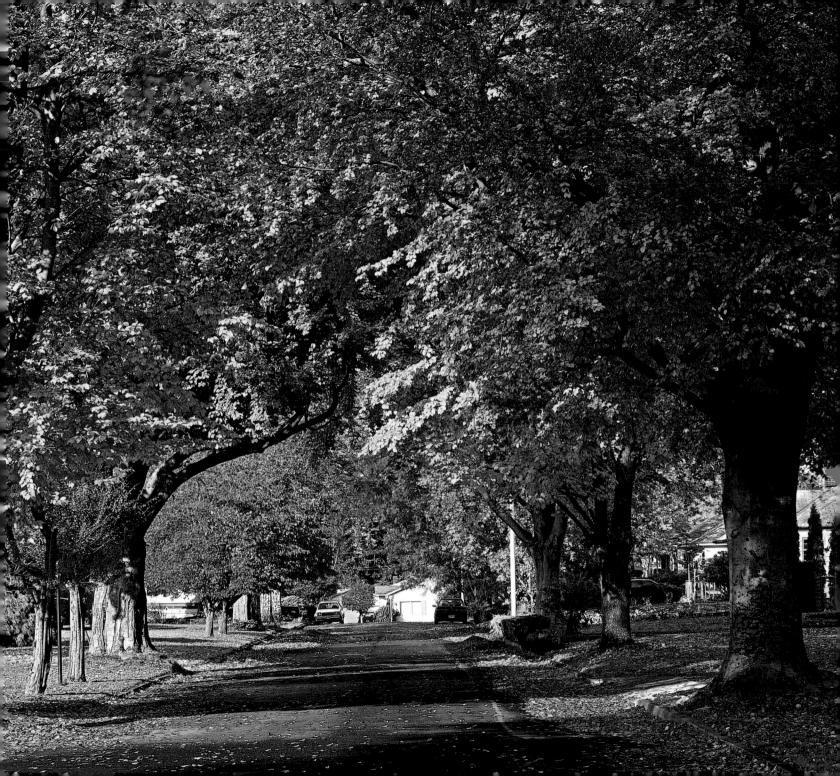

ABOVE: A float from the Grand Floral Parade, the signature event of the annual Portland Rose Festival. Nearly 500,000 spectators line the 4.3-mile parade route from Memorial Coliseum through downtown Portland.

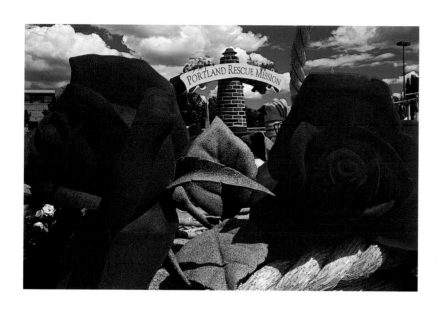

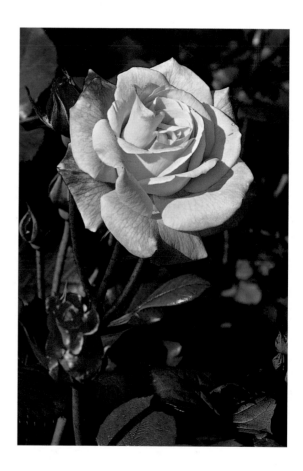

ABOVE: Giant red roses frame an image of the Portland Rescue Mission float. Thousands of workers volunteer their time to decorate the exquisite floats in the Grand Floral Parade.

RIGHT: Beautiful roses, such as this one from a Multnomah garden, thrive in Portland's moist, temperate climate.

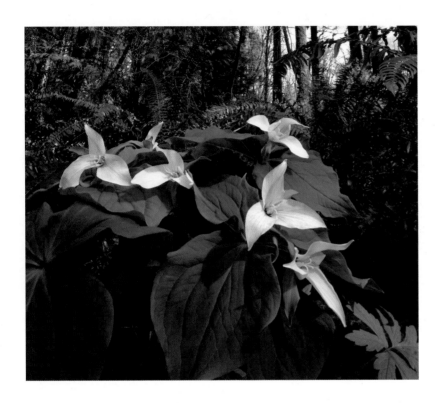

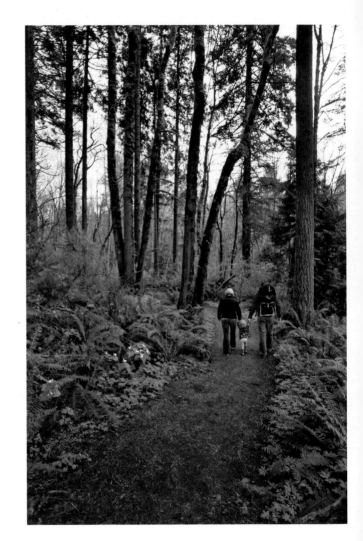

THESE PAGES: Trillium (above) lines the many hiking and cycling trails (right) in 645-acre Tryon Creek State Natural Area, located minutes from downtown Portland. A graceful stone bridge (facing page) takes visitors across Tryon Creek, one of the only streams in the metro area with a run of steelhead trout.

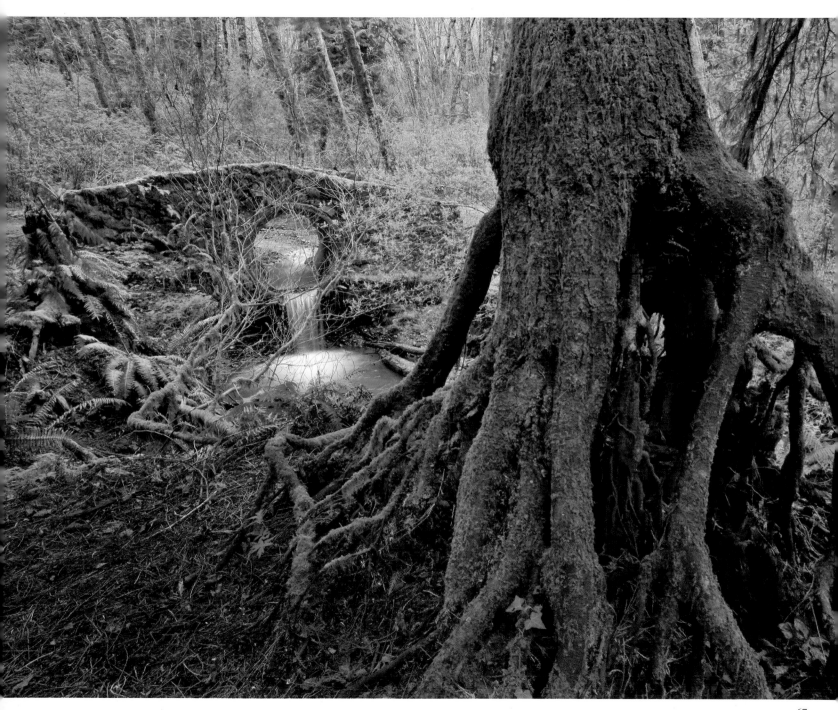

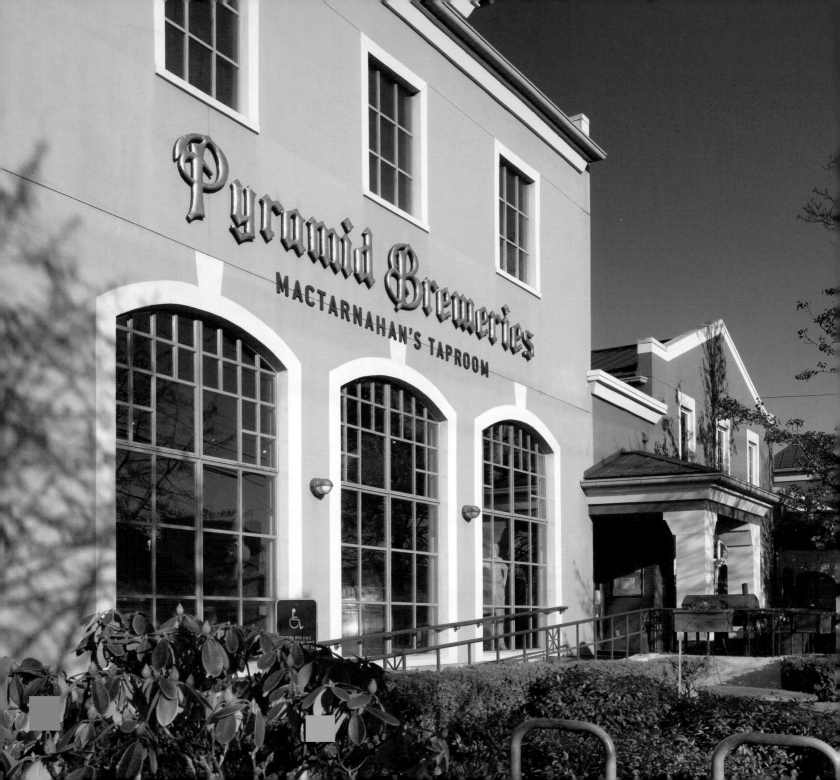

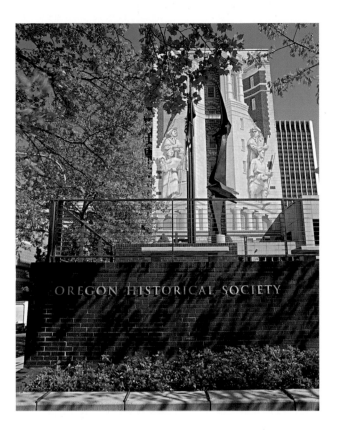

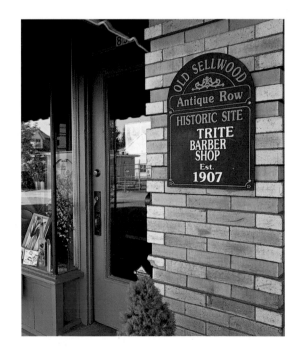

ABOVE: Murals of Lewis and Clark Expedition members adorn the exterior of the Oregon Historical Society, commemorating the Corps of Discovery's travels through the area in 1806.

RIGHT: The Sellwood district of Southeast Portland was once an independent community until it was annexed by Portland in 1893. Now known as "Antique Row," the area bustles with antique dealers operating from Victorian homes and refurbished storefronts, such as the 1907 Trite Barber Shop.

LEFT: MacTarnahan's Taproom, part of Pyramid Breweries, is both a brewery and a gathering place. The landmark building was once home to Portland Brewing.

RIGHT: A boy cools off in the Salmon Street Springs Fountain, designed by Robert Perron, which is located in Tom McCall Waterfront Park. The fountain features 185 water jets and recycles 4,925 gallons of water per minute.

FAR RIGHT: An evening sun highlights the sailboats moored at the Columbia River Channel at Tomahawk Island, a popular spot with boaters.

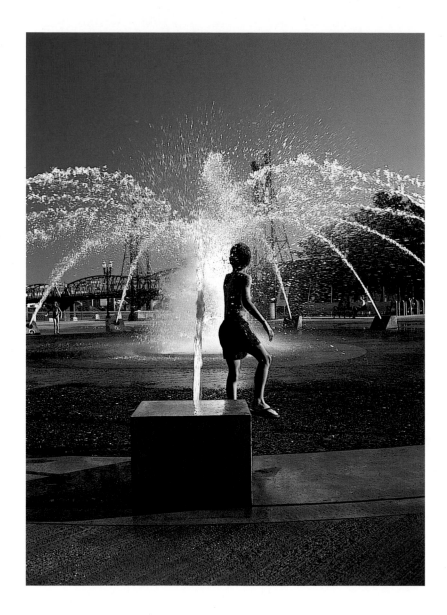

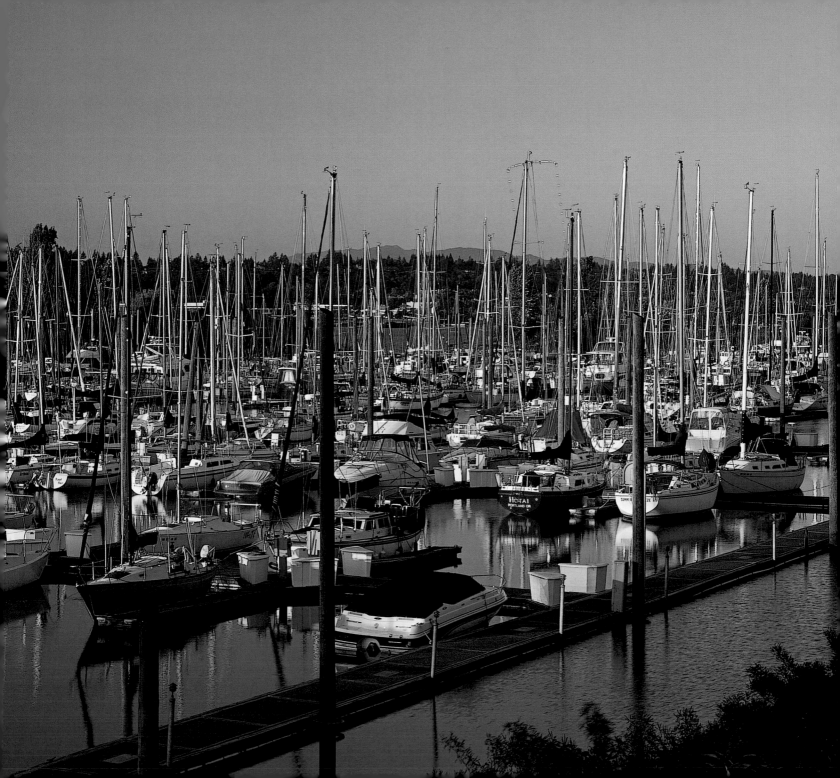

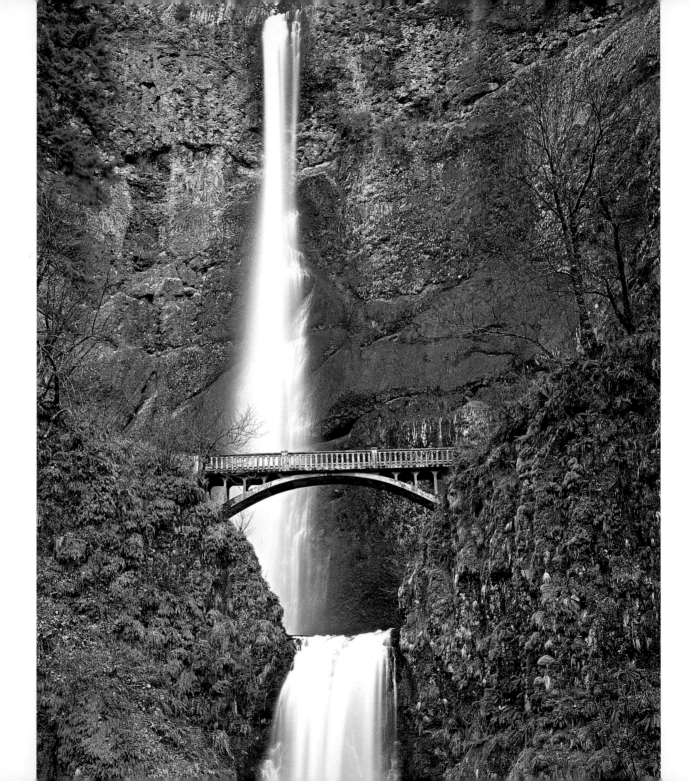

FACING PAGE: The waters of Multnomah Falls, located in the Columbia River Gorge National Scenic Area, drop 620 feet down Larch Mountain. The Benson Bridge, which spans the upper and lower tiers of the falls, was crafted in 1914 by Italian stone masons. At the base of the falls is the historic Multnomah Falls Lodge.

BELOW: Profuse blooms of more than 2,500 rhododendrons, azaleas, and other plants thrive at the Crystal Spring Rhododendron Garden, which was started in 1950 as a test garden for new rhododendron varieties.

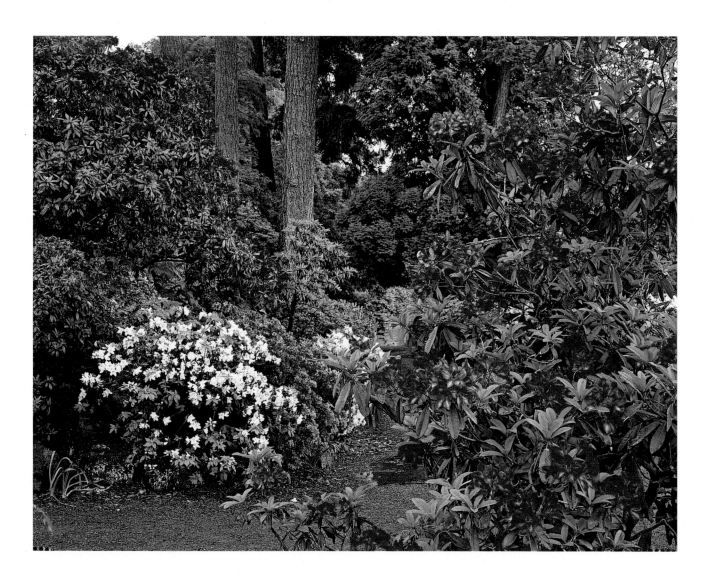

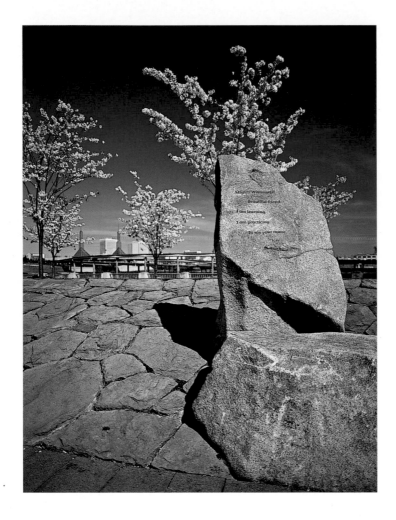

ABOVE: Surrounded by one hundred cherry trees, this marker is part of the Japanese-American Memorial Park, which was dedicated on August 3, 1990, to the memory of those Japanese who were sent to inland internment camps during World War II.

RIGHT: Bicycling the 40-mile loop trail along Marine Drive and the Columbia River.

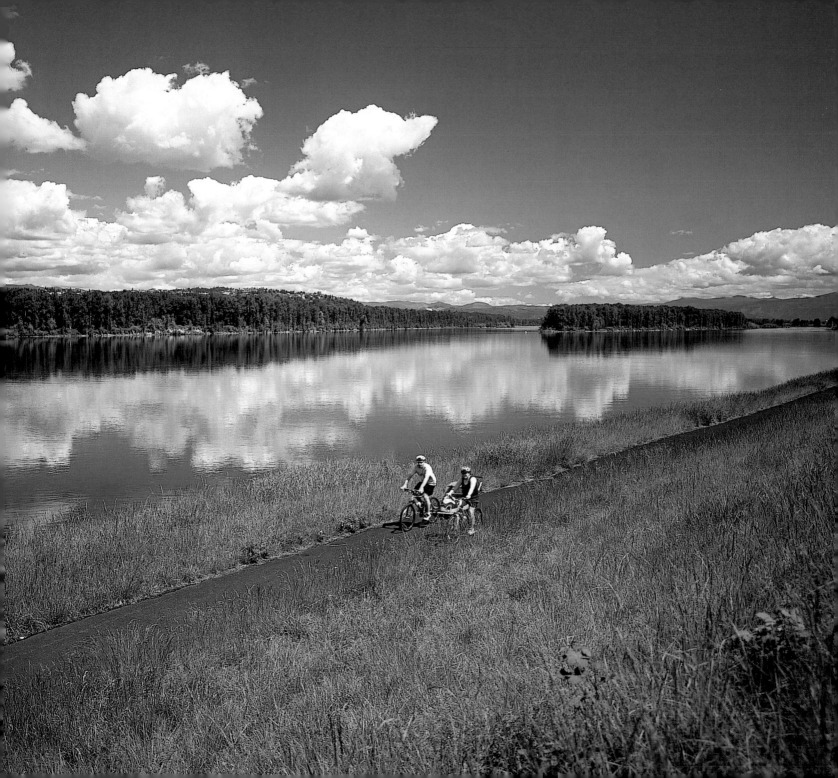

RIGHT: As many as 100 boats compete in the Portland-Kaohsiung Sister City Dragon Boat Races, held on the Willamette River during the annual Portland Rose Festival.

FACING PAGE: At the entrance of downtown Portland's Chinatown, the Chinatown Gateway is decorated with seventy-eight dragons and fifty-eight mythical characters. The Chinese characters on the north side mean "Portland Chinatown" and on the south side, "Four Seas, One Family."

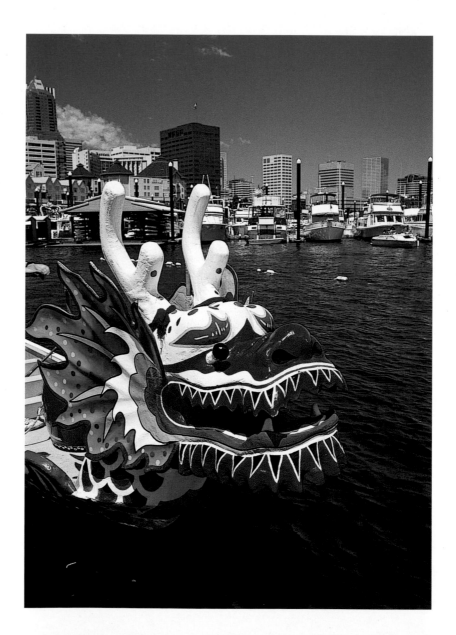

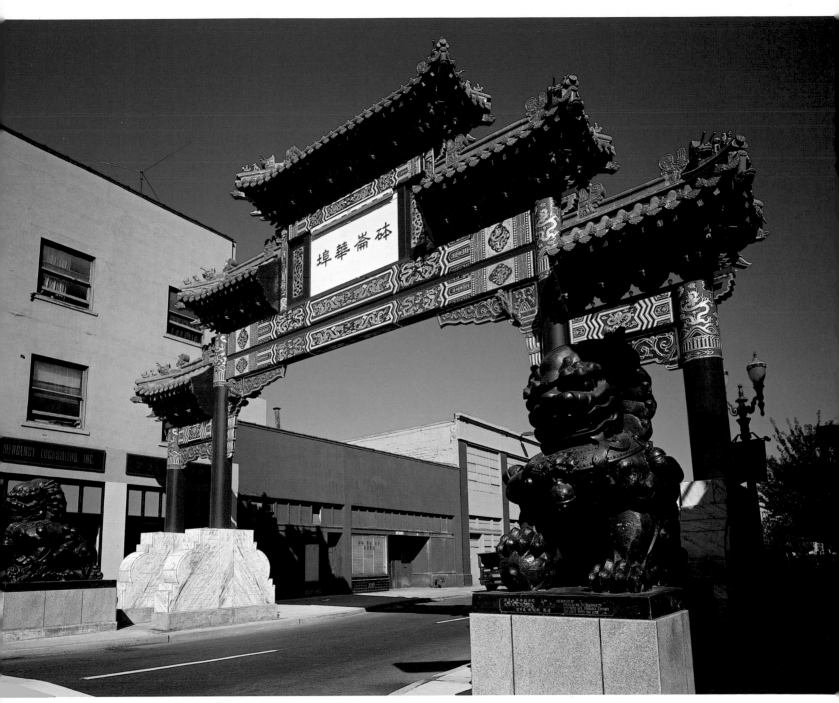

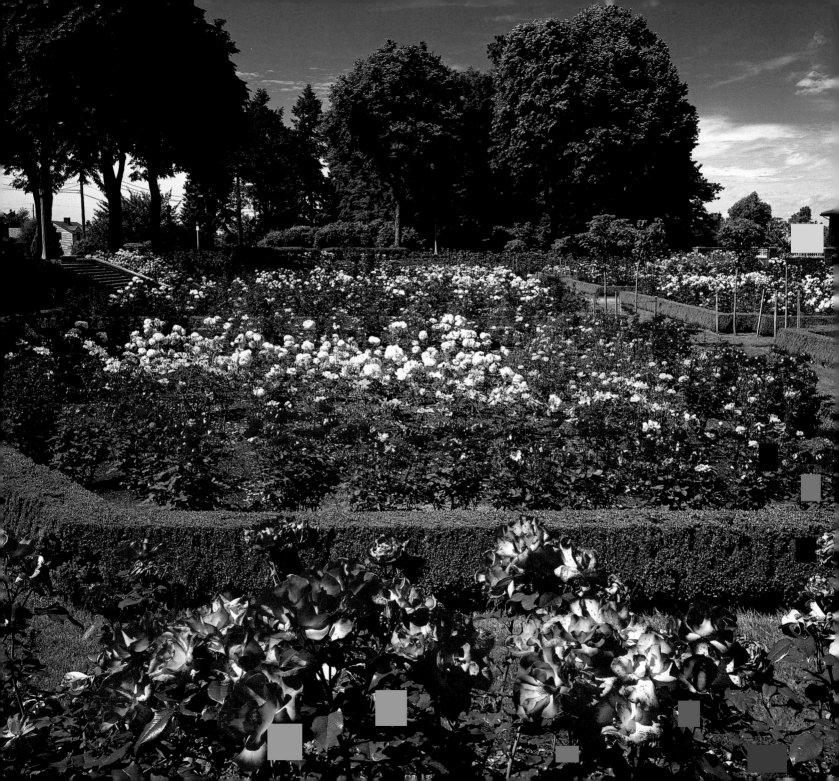

LEFT: One of Portland's first public rose gardens, the two-acre Peninsula Rose Garden features 8,900 plants and 65 rose varieties.

BELOW: This Garden of Solace, located in the Oregon Vietnam Veterans Memorial in Hoyt Arboretum, is part of a memorial designed by the landscape architecture firm of Walker Macy and features curved black granite walls listing the names of all Oregon residents who died in Vietnam or who are missing in action.

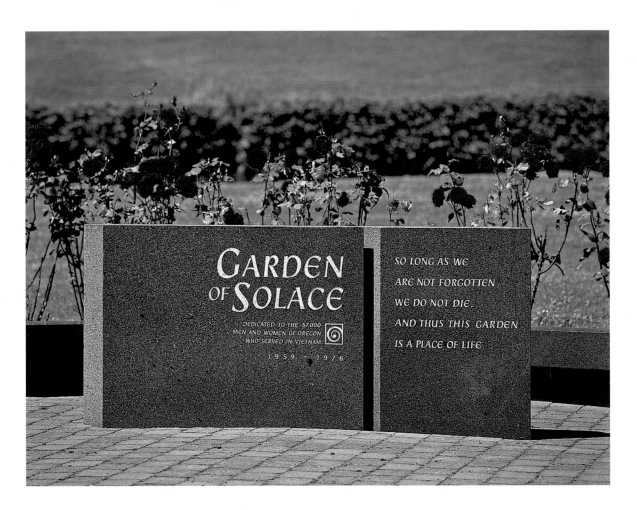

Steve Terrill

Self-taught photographer Steve Terrill, a native of Portland, Oregon, has been trekking throughout the United States since 1980, with a focus on the Northwest, seeking to preserve on film the grandeur of nature.

Steve's career began in April 1980 when he was hired by Beautiful America Publishing as one of their staff photographers. His career exploded in May of that year when he captured the eruption of Mount St. Helens on the morning of May 18, 1980. Later that same year, one of Steve's photographs of the eruption was presented to President Jimmy Carter while he was in the area to view the destruction caused by the volcano.

In 1982 Steve began his career in freelance photography. Since that time his work has appeared in numerous books, calendars, and magazines with several organizations, including Audubon, National Geographic Publications, Sierra Club, *Travel & Leisure,* Coldwater Creek, *National Wildlife, Outdoor Photographer,* Nature's Best, and *Readers Digest.* He was a contributing editor at *Outdoor and Travel Photography* and is a field editor at *Country* magazine. Steve is also a regular contributor to numerous Oregon tourism publications.